Painted Botanical
COLLAGE

Create Flowers, Succulents, and Herbs from **Cut Paper** and **Mixed Media**

Tracey English

FAIR WINDS

Brimming with creative inspiration, how-to projects, and useful information to enrich your everyday life, Quarto Knows is a favorite destination for those pursuing their interests and passions. Visit our site and dig deeper with our books into your area of interest: Quarto Creates, Quarto Cooks, Quarto Homes, Quarto Lives, Quarto Drives, Quarto Explores, Quarto Gifts, or Quarto Kids.

First Published in 2018 by Quarry Books, an imprint of The Quarto Group, 100 Cummings Center, Suite 265-D, Beverly, MA 01915, USA.

T (978) 282-9590 F (978) 283-2742 QuartoKnows.com

Quarry Books titles are also available at discount for retail, wholesale, promotional, and bulk purchase. For details, contact the Special Sales Manager by email at specialsales@quarto.com or by mail at The Quarto Group, Attn: Special Sales Manager, 401 Second Avenue North, Suite 310, Minneapolis, MN 55401, USA.

10 9 8 7 6 5 4 3 2 1

ISBN: 978-1-63159-529-5

Digital edition published in 2018
eISBN: 978-1-63159-530-1

Library of Congress Cataloging-in-Publication Data
Names: English, Tracey (Tracey A.), author.
Title: Painted botanical collage : create flowers, succulents, and herbs from cut paper and mixed media / Tracey English.
Description: Beverly, MA : Quarry Books, 2018.
Identifiers: LCCN 2018027754 | ISBN 9781631595295 (trade pbk.)
Subjects: LCSH: Paper work. | Mixed media (Art) | Flowers in art. | Collage--Technique.
Classification: LCC TT870 .E55 2018 | DDC 745.54--dc23 LC record available at https://lccn.loc.gov/2018027754

Design: Kathie Alexander
Page Layout: Kathie Alexander
Photography: Philip Wilkins

Printed in China

Dedication

For my husband Lutz, stepdaughter Lea, and sons Noah and
Eryn, thank you for always being there for me and supporting
my creative dreams.

Contents

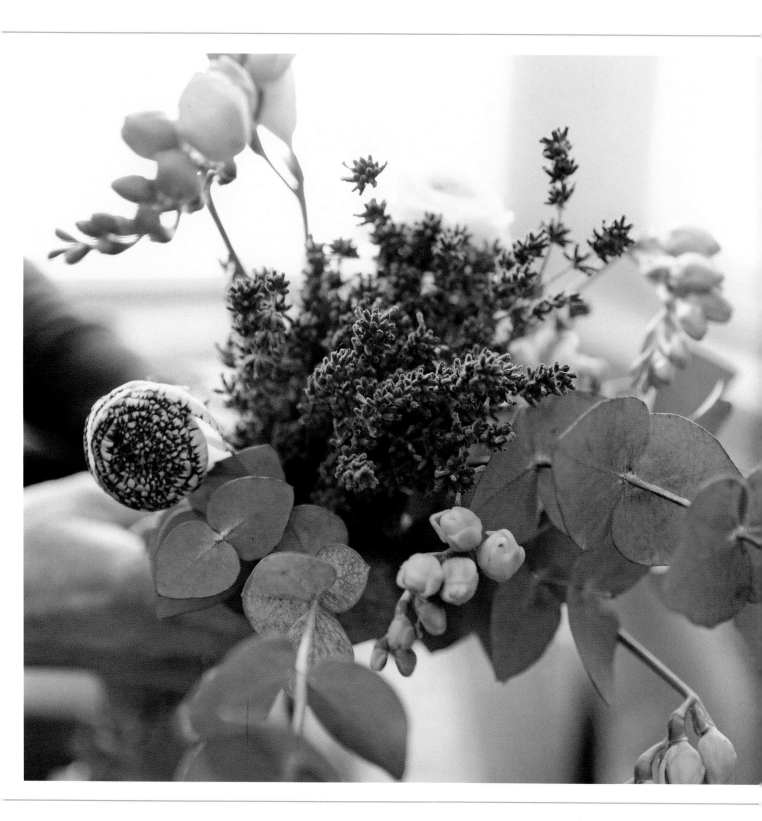

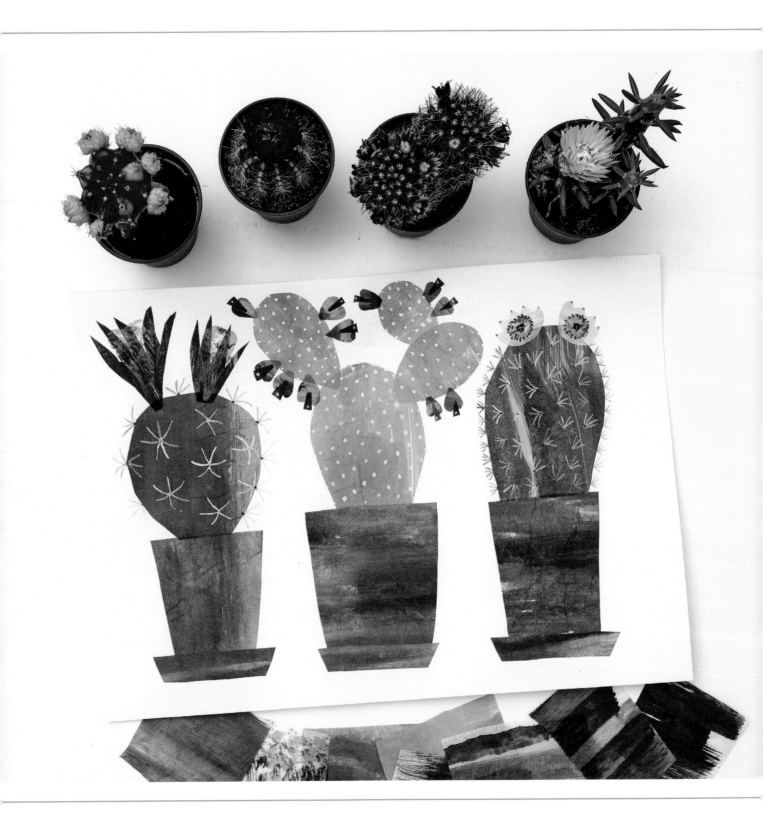

Introduction

Collage is an art form that can produce a wide range of visual styles. Its accessible methods make it fun and approachable for beginners, while remaining an exciting medium for seasoned professionals. In this book, we will follow a step-by-step process to create beautiful floral studies using a variety of collage techniques. The introduction to each project will also share some interesting details about each flower.

Collage can be created by using recycled papers, pages from magazines, colored papers, paper that you have created yourself, or even a combination of all four. There are no hard-and-fast rules, but the variety of projects included here demonstrate a wide range of approaches. Each of the flowers is simplified into its prominent and easily identifiable shapes, and the color combinations and textures open up endless possibilities for exploring new ways of working.

Chapter 1
Getting Started

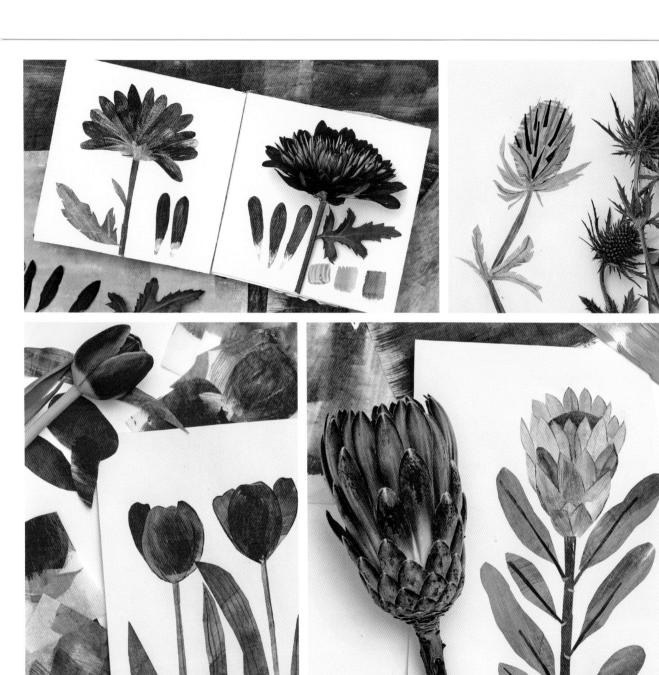

Finding Inspiration

Where to begin when there are so many choices and amazing shapes, colors, and textures found in every type of plant and flower? Get inspired by visiting a nearby florist or taking a walk around your garden, local parks, or plant center. A gardening magazine can be a useful reference, and there are always images on the Internet. I started my flower collages as a sketchbook project, making small studies of plants and flowers that I found in our tiny city garden over one summer. By looking at the shapes and textures, you can re-create collage papers inspired by the nature that surrounds you. I love the way nature grows in unity and creates patterns all on its own—leaves intertwine and flowers snake around each other, taking care to intermingle at just the right moment to create perfect harmony and a whole wealth of inspiration. A single houseplant, a leaf sprig collected on a walk, or a rose in a vase is enough to get you started. Simple shapes and solid colors are the perfect way to begin snipping out your first creation.

Materials and Tools

The following is a complete list of tools and materials that can be used to create the projects in this book. Start with some basics—scissors, craft paints, scrap papers, glue, fine-point pens, a sheet of stiff paper—and get started. As you continue to experiment, you can gather more supplies, try different adhesives to find your favorite, experiment with more sources of paper, use different drawing media for detail work, and experiment with substrates.

Cutting

- Scissors (large/small): I prefer to use children's scissors, as they are nice and small, making it easy to cut tiny pieces.
- Scalpel blade or craft knife for awkward shapes

Adhesives

- PVA craft glue
- Mod Podge
- Gel medium
- Glue stick
- Paper for Collage
- Cartridge paper
- Deli paper
- Tissue paper
- Magazines and newspapers
- Found papers

Color and Line

- Liquid acrylics
- Colored pencils
- Fine-liner pens

Substrates

- Heritage paper
- Card stock
- Bristol board
- Found paper
- Watercolor paper

Tools

- Brushes
- Sponge
- Old loyalty/credit card
- Paper palette or plate
- Old jam jars for water and glue

Chapter 2
Creating Background Papers

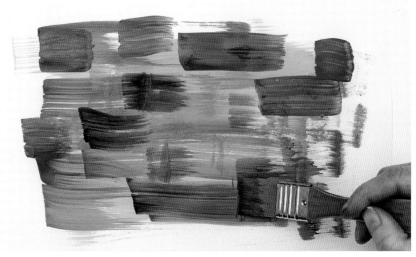

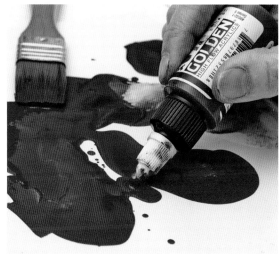

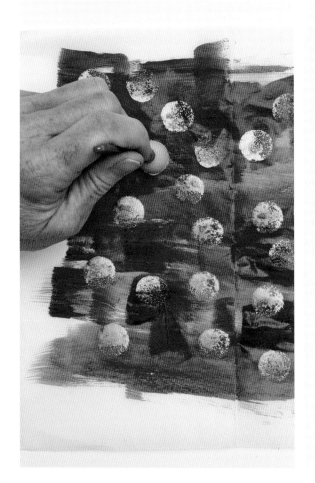

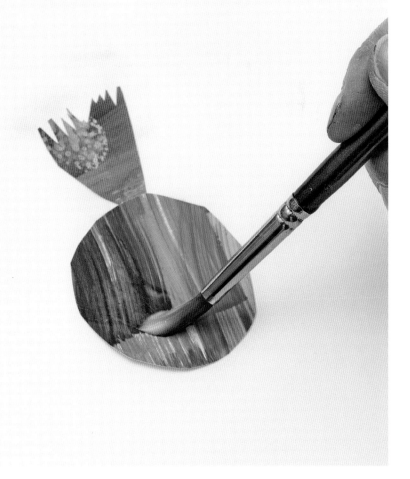

Color Mixing Strategies

For botanical collages, it is useful to have a varied collection of different green paints. Using different hues together, you can create great depth and texture on the collage papers to create papers for the leaves and stalks.

Flowers are often much more diverse. Sometimes, you will want to mix analogous colors (colors that look similar) to try and reproduce the quality of the petals. Sometimes, you will want to combine complementary colors (colors on opposite sides of the color wheel).

Basic Collage Techniques

Collage is the process of cutting out shapes from paper and adhering them onto a final surface. It is a wonderful, flexible, and creative medium and one that doesn't require extensive art-making experience. It's as easy for beginners to learn as it is for seasoned professional artists.

Collage can be created with recycled paper, magazine pages, colored papers, paper that you have painted yourself, or even a combination. There really are no hard-and-fast rules.

The flowers we will create are simplified into more manageable shapes and color combinations. The textures you will observe open up endless possibilities for exploring new ways of working.

Types of Collage Paper

Cartridge Paper: This is a high-quality paper used for illustration and drawing. It's a great choice if you want to create lots of texture and depth.

Deli Paper: Deli paper is robust and good for creating texture; is slightly translucent; and is easy to cut. It's a good paper to use to build up layers.

Tissue Paper: Tissue paper is more fragile than other papers but gives a delicate effect. Textures can be created, but the paper must not be allowed to become soggy. It is also easy to cut.

Magazine Images and Found Papers: These can be painted over to add more texture and depth or to obtain a more accurate color.

Setting Up a Workspace

An empty table with good natural light or a desk light is all that is necessary to work with collage techniques. Place your flowers or photographic reference on a white sheet of paper, so that there are no distractions and it's easier to see the different textures, colors, and forms.

Place some old newspaper on the table and some kitchen paper, newspaper, or a tea towel to the left-hand side of your workstation; this is for drying the prepared collage papers once painted. The chosen paint hues, palette, scissors, and paintbrushes can be placed on the other side of your workspace.

Cleaning Up and Storage

A mini vacuum or a dustpan and brush are handy for getting rid of all the little bits of paper snips from your collage creation.

Keep larger pieces of leftover collage paper to use for future projects. A flat box or small chest is useful for this, especially if you want to store paper in color groups.

It's always handy to have a trolley or rolling cart to keep paints, glue, brushes, and other equipment; you can be fairly mobile about where you work, and it's easy to stash your supplies when you're finished creating.

Creating Your Own Background Papers

1. Choose the flower or plant you wish to create.

2. Select the colors that can be seen within the object.

3. After selecting the paint, squeeze or pour the chosen hues onto the palette.

4. Arrange the paper to be collaged on some old newspaper and then loosely mix the colors together on the palette before applying them to the chosen paper. My preference is to use a wide, flat-ended brush to apply the paint, but you can use a brush of your choice. Layer paint and add texture as you go along to create the colors and patterns in the plants. (See the two examples that follow.)

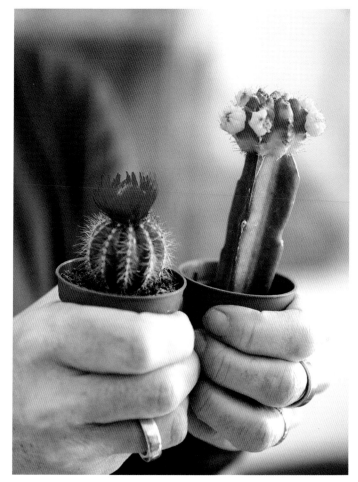

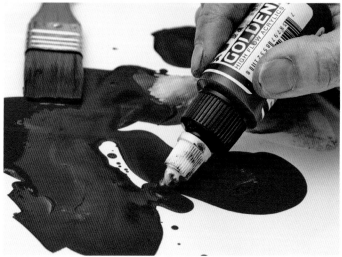

Leaf Example Series

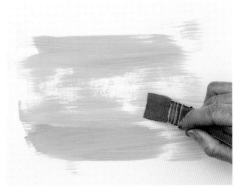

1. Apply the base color in a loose fashion. Make wide strokes, dab or drag your brush, or apply the paint in irregular fashion.

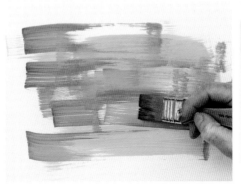

2. Apply a second shade of paint, allowing some of the first color to show through.

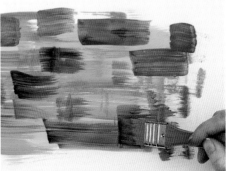

3. Add a third color to create more depth.

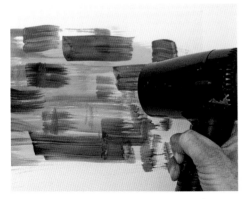

4. Use a hairdryer to speed up the drying time, if desired.

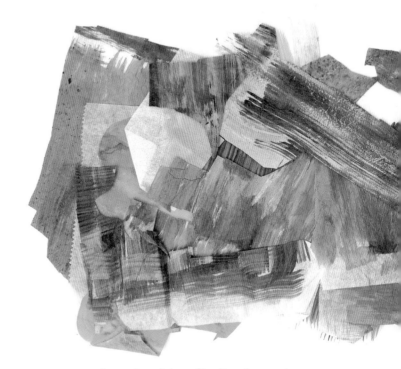

Several swatches of leaf background papers

Petal Example Series

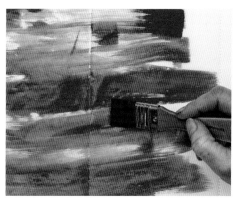

1. Apply your base color.

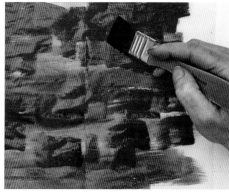

2. Apply a second shade and move the paint around to blend some of the shades.

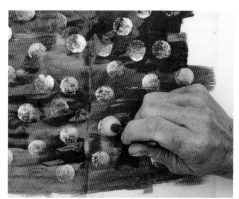

3. Use a dauber or another tool to add spots of a contrasting color.

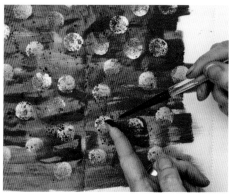
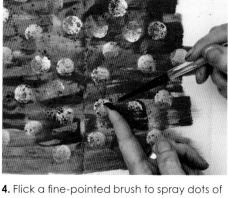

4. Flick a fine-pointed brush to spray dots of color around the surface.

Once your paint layers are complete, place the papers to one side to dry on some kitchen towels, newspapers, or a drying rack.

Put the paint palette to one side but keep it handy just in case you want to use the spare paint to finalize any details of your finished collage.

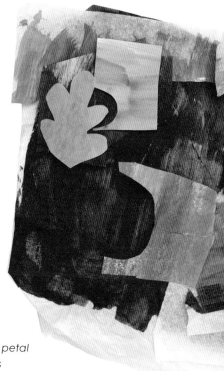

Several swatches of petal background papers

> **TIP** **Working with tissue paper**
>
> When working with thin sheets like tissue, keep the brush fairly dry and work quickly, as the paper tends to get soggy and will fall apart. Keep gently lifting it up as you work to prevent it from sticking to the newspaper. Allow it to dry in between each paint layer if you want to add more colors and textures.

Visual Guide to Making a Flower Collage from Start to Finish

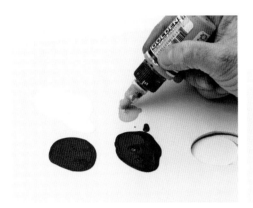

1. Place your paint colors on your palette.

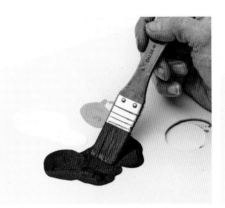

2. Use a brush to blend your colors. Mix similar hues—for example two shades of red—to create a complex color.

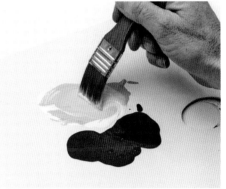

3. Add white to lighten a shade, as shown here with yellow.

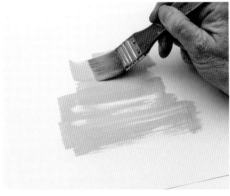

4. Starting with your lightest color, apply it to your background paper using a wide brush.

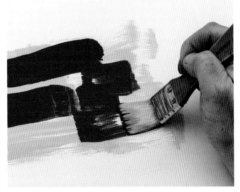

5. Add a second color over the top to create another layer.

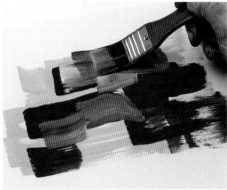

6. Continue to blend the colors.

Continued

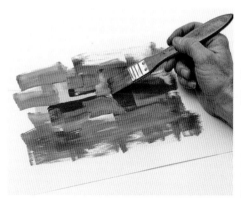

7. Fill the entire sheet and blend until you are satisfied with the result.

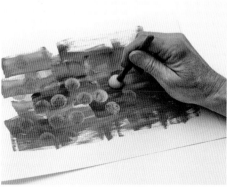

8. Use a dauber or similar tool to add dots of a highlight color.

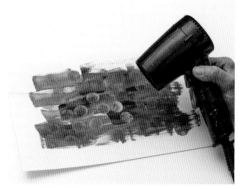

9. Use a hairdryer to set the paint.

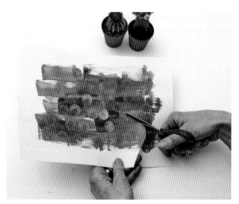

10. Begin to cut the largest main shapes from your background color, using your sample to reference the size and appearance.

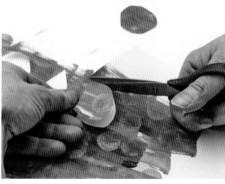

11. *Look for interesting areas of colors to cut your shapes from.*

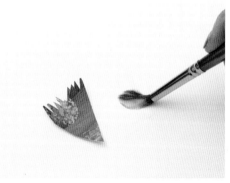

12. Use the tips of your scissors to cut fine details.

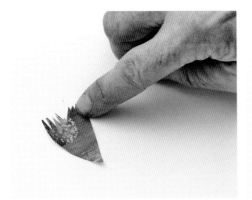

13. Apply adhesive to the base paper.

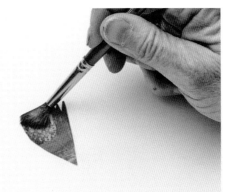

14. Press your shape onto the surface.

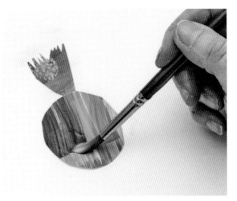

15. Coat the shape with adhesive or medium to adhere.

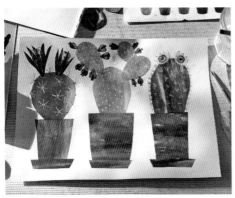

16. Apply the next shape using the same technique.

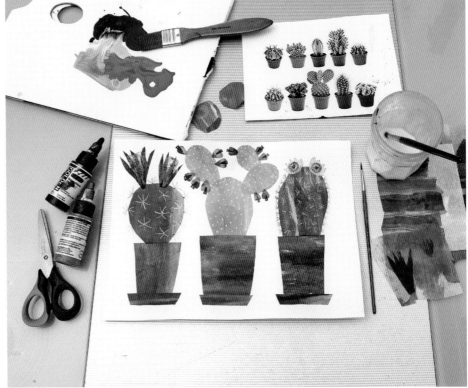

Enjoy your final composition!

Chapter 3
Flower Collage Projects

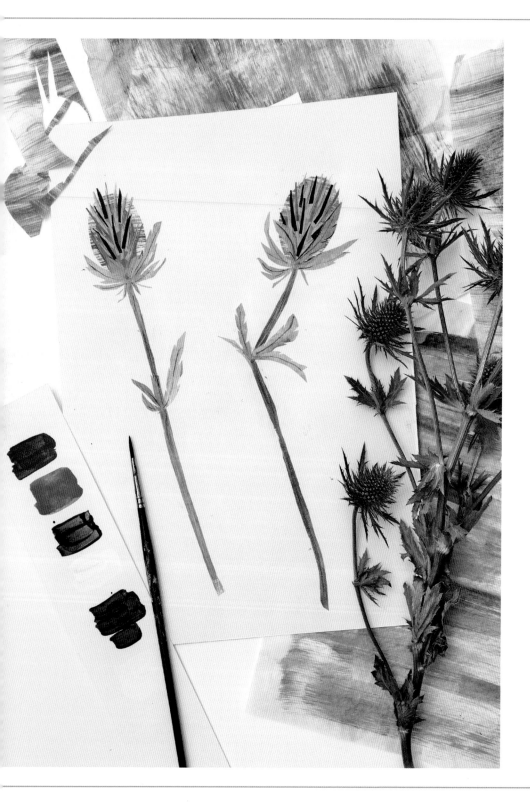

Thistle

Thistle is the name given to a group of flowering plants generally characterized by having prickles on the leaves and stems. They have a bad reputation for being a weed, but have a lovely bloom, which comes in a variety of colors, although they are most commonly found in shades of purple. They are beloved by bees and butterflies. The thistle has been the national emblem of Scotland for many centuries and in fact, is the oldest recorded national flower. They are very easy to dry, and then will last indefinitely.

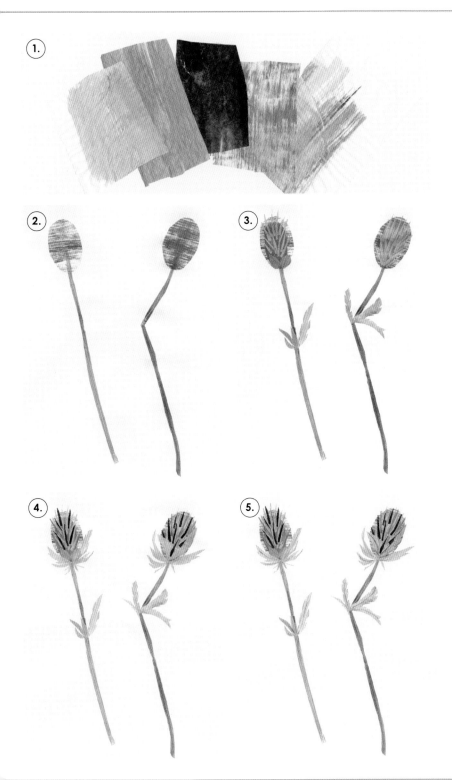

Colors Used:

Sepia

Yellow Oxide

Permanent Violet Dark

Titanium White

Indigo

Step 1: Mix the coordinating paint colors and prepare the background papers with suitable textures that are inspired by the different surfaces of the dried thistle.

Step 2: From your background papers, cut out the stem and textured thistle head. Position them on your final surface and glue in place.

Step 3: Adhere the first leaves to the stem, the head of the thistle to the top of the stem, and the initial spikes.

Step 4: Add some more spikes in darker colors to provide contrast and depth. Finally, adhere the leaves around the flower head.

Step 5: With a fine brush or black permanent fine-line marker, add some fine lines to define veins on the leaves. Enhance any other elements that you wish to highlight to finalize your collage.

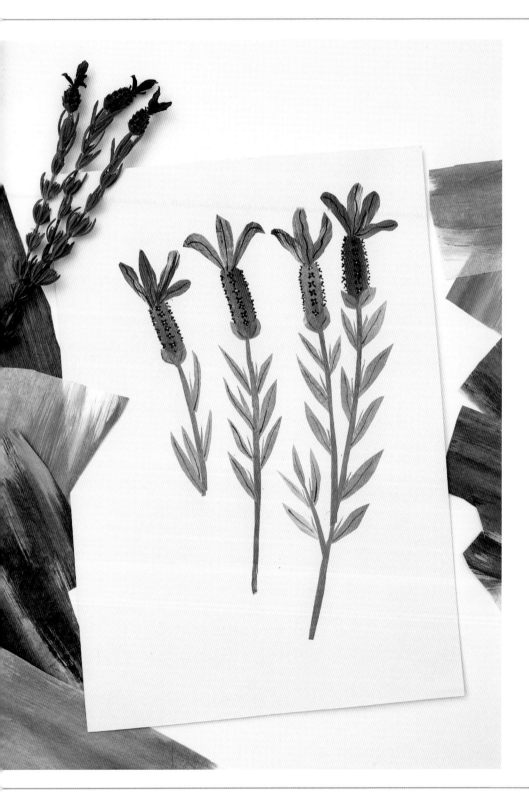

Lavender

Lavender is an easy-to-grow evergreen shrub that is found in temperate climates. It is drought tolerant and loves sunny locations. In summer, it produces masses of scented flowers. It can be used as culinary herb and to extract essential oils.

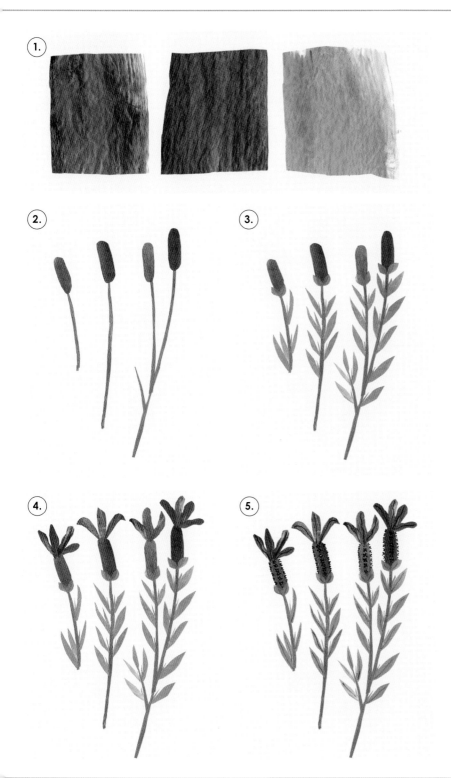

Colors Used:

Teal

Olive Green

Sepia

Dark Violet

Titanium White

Step 1: Blend the coordinating colors and prepare the background papers with textures related to the lavender. A drybrush technique can help add structure to the papers.

Step 2: From the background papers that you prepared, cut out the green stem and the smooth head of the lavender, place in position, and glue to your final paper.

Step 3: Cut the leaves and arrange on the stems, and cut some smaller, shorter ones for around the flower head. Adhere all the pieces to the final surface.

Step 4: Using the alternative violet paper, cut out the shapes for the petals, place them on the upper part of the flower head, and glue down.

Step 5: With a fine brush and a darker tone of paint, add some fine lines on the leaves and petals. Create some small flowers on the lavender heads and finalize with a little dot of white in each detail.

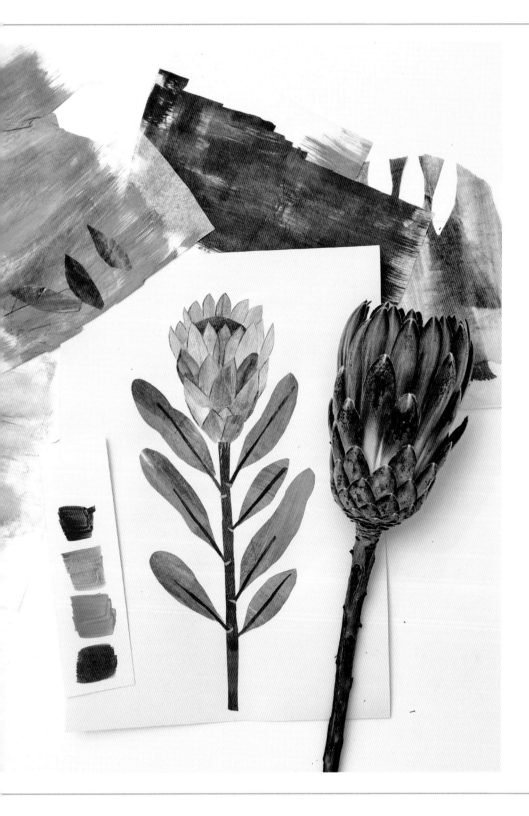

Protea

Protea are found in both Mediterranean and tropical climates; they flower during springtime. The genus *Protea* originates from South Africa and is supposed to be a symbol for change and hope. Nowadays, they are mainly used for decorative purposes. Australia now has the greatest diversity of Protea species, with over 850 different types, followed closely by South Africa with over 330 types.

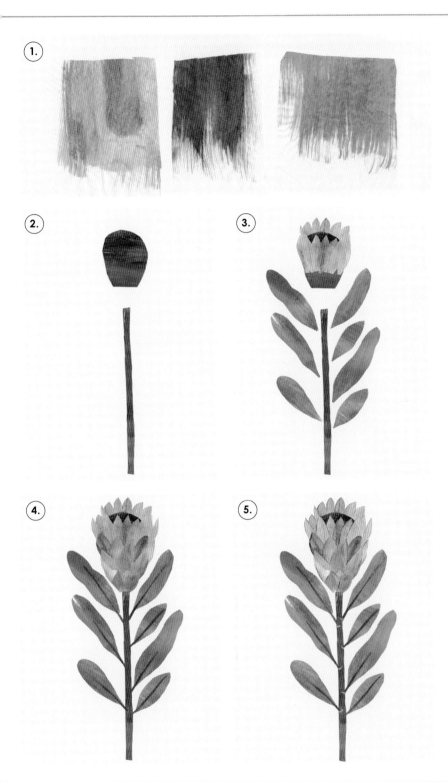

Colors Used:

Process Magenta

Olive Green

Teal

Burnt Sienna

Titanium White

Step 1: Combine the colors to create the right shades for the background papers. Add some textures and different tones to give variety and depth to the collage sheets.

Step 2: Using the paper you just created, cut out a stalk and the center of the flower head. Arrange on the final surface and glue in place.

Step 3: Carefully, cut out some petal shapes from the light pink paper, making sure there are enough to go all the way around the flower head. Adhere the smaller ones on the top first, finishing with the longer petals along the front. Cut and arrange some leaves of various sizes. Glue everything in place.

Step 4: With a dry brush, add some olive green texture on some of the prepared pink paper to create a slightly different tone for the lower petals. Cut out and arrange on the flower. Add some Burnt Sienna strips to the leaves. Adhere them all to the collage.

Step 5: Cut out some tiny pieces of green and carefully glue them to the base of the leaf stalk. With the Process Magenta, define some of the petals to accent them and enhance the flower.

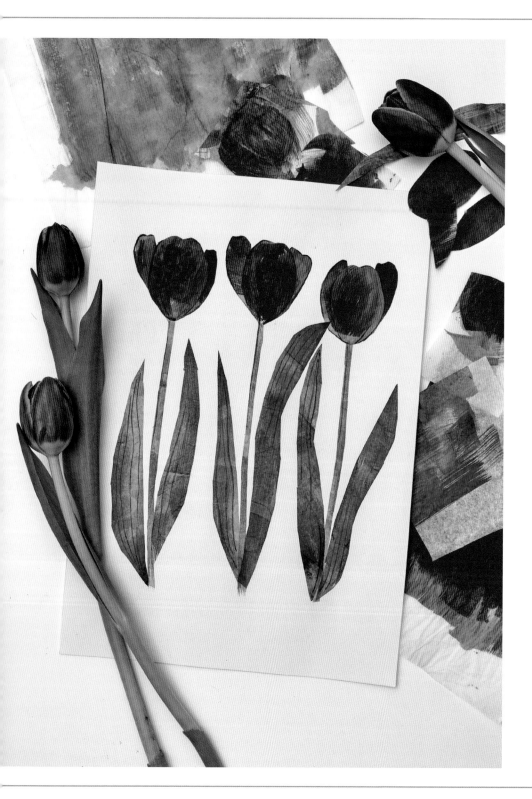

Tulip

Tulips are one of the most popular bulbs, adored for their huge selection of colors and bold shapes. Ideally, they should be planted in the autumn for a spring bloom. Originally, they were thought to be cultivated in tenth-century Asia.

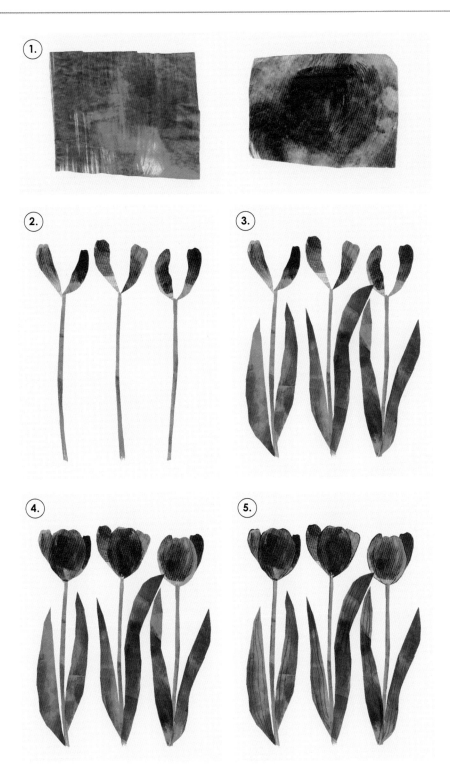

Colors Used:

Diarylide Yellow

Alizarin Crimson

Naphthol Red Light

Permanent Green Light

Light Green

Turquoise

Step 1: Blend the paint colors on the collage paper, taking inspiration from the tulip petals and blending the textures together. Mix the greens to color some papers for the leaves.

Step 2: From the prepared papers, cut out three strips for the stems and the shapes for the outside petals. Position the pieces on the final surface and glue in place.

Step 3: Arrange and adhere the main leaves on either side of the stems.

Step 4: Cut and add a final central petal on each flower head.

Step 5: With a fine brush or colored fine-liner pen, highlight the shapes of the leaves and petals so that the features stand out.

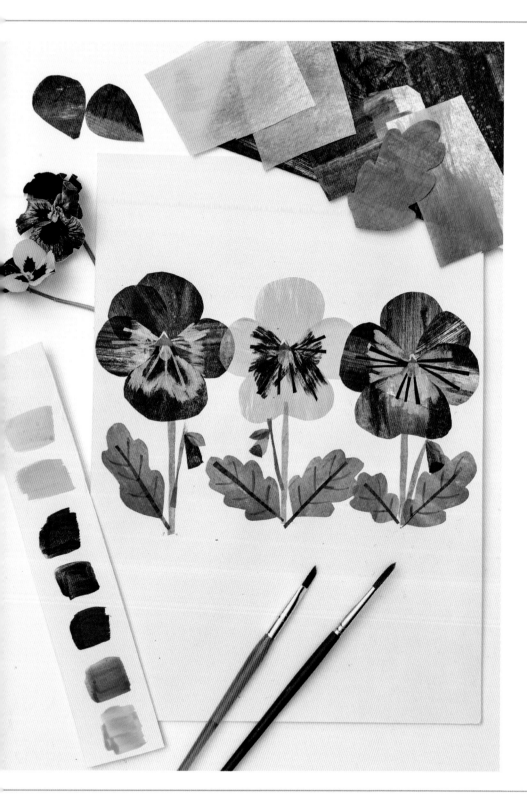

Pansy

The pansy is a cultivated garden flower that grows well in sunny, well-drained soils during the spring and fall. They are brightly colored plants that originally derived from the genus *Viola*, which is found in Europe and Western Asia. They are edible and have a mild, minty flavor.

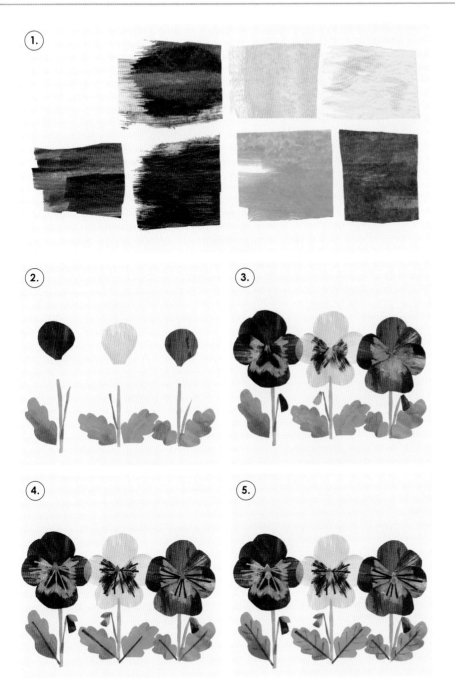

Colors Used:

Light Green

Permanent Green Light

Quinacridone Magenta

Alizarin Crimson

Permanent Violet Dark

Hansa Yellow Medium

Diarylide Yellow

Titanium White

Step 1: Blend the colors inspired by the pansy flowers to create papers suitable for the collage. They have many great colors, so have fun with your color choices and combinations.

Step 2: From the prepared papers, cut out the back petals, the leaves, and the stems of the pansies. Arrange on your chosen surface and adhere in place.

Step 3: Cut out the remaining petals and create some contrasting highlights on these petals with the drybrush technique. Position them and glue down.

Step 4: Simplify the detail by adding some contrasting color strips and a central triangle as a feature.

Step 5: Finally, cut out and create a yellow center for the flower heads. Add some definition by highlighting the central stigma with a white fine-liner pen. Enhance any other elements with a thin brush and slightly darker hue.

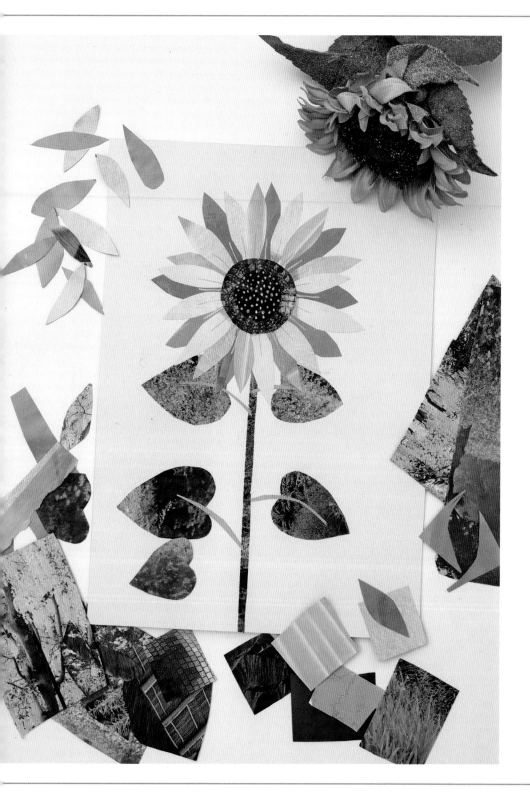

Sunflower

The sunflower is an annual plant that has a large flower head with yellow petals and can grow up to 10 feet (3 m) in height. They are an important source for sunflower oil, and the seeds are often used as a tasty snack or ingredient for other foods. This flower grows best in full sun and wet, fertile, well-drained soil. The sunflower is the state flower of Kansas.

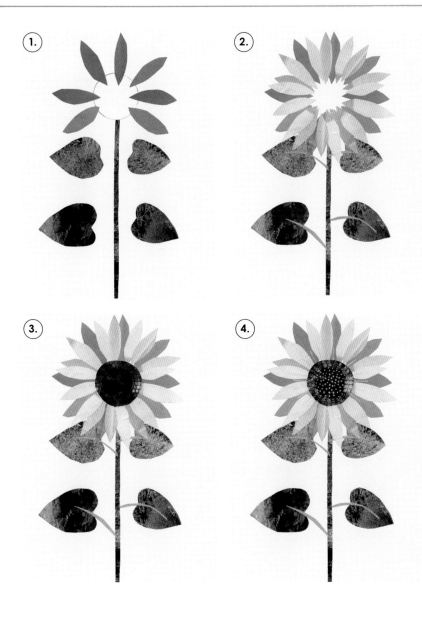

1.

2.

3.

4.

Colors Used:

Found colors: magazine pages

Grass Green

Olive Green

Chocolate Brown

Warm yellows

Step 1: Select some green- and yellow-colored papers from a magazine. Cut a fine, straight stem for the flower stalk and lay it in the middle of the prepared paper. Above the stem, draw a circle with pencil to indicate where the flower head will be located. Cut and arrange seven yellow petals around two-thirds of the circle and cut some leaf shapes for either side of the stem. Once everything is in place, adhere to the final paper.

Step 2: First, select a lighter green and cut and glue down a stem for each of the leaves. Then, choose different colored yellow papers and cut out enough petals to go around the marked-out center, taking care to arrange them in a variety of yellows, and glue down in place.

Step 3: Find two alternate pieces for the center and cut into circles, making sure that one is smaller in size and darker in shade. Position in place and glue one on top of the other.

Step 4: Mix a little yellow and white acrylic paint together to make a pale shade, which can be used to add some definition to the petals and highlight the seed heads with some dots and texture.

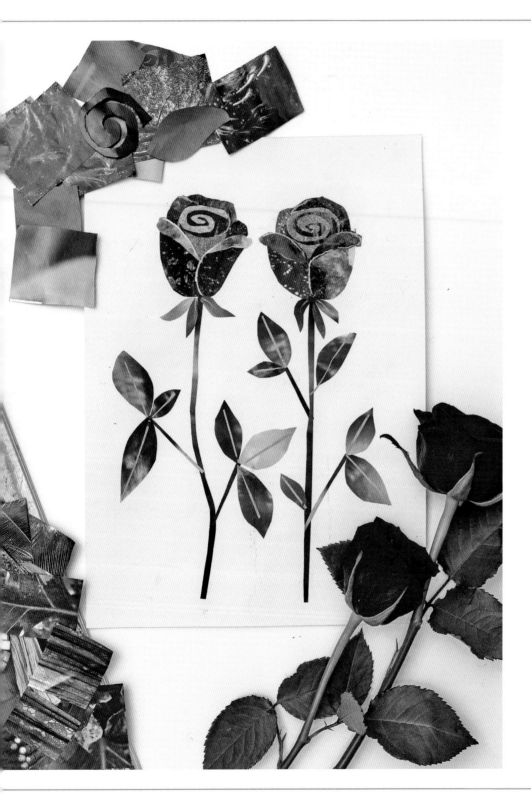

Rose

Roses are popular, easy-to-grow perennial plants that come in many colors, scents, and sizes. The plants can be found as shrubs, climbers, or trailing plants, and the stems often are covered in sharp prickles. They are generally easy to maintain and can last for many years. Flowering continuously through the summer and autumn, many will be happy in either sun or shade.

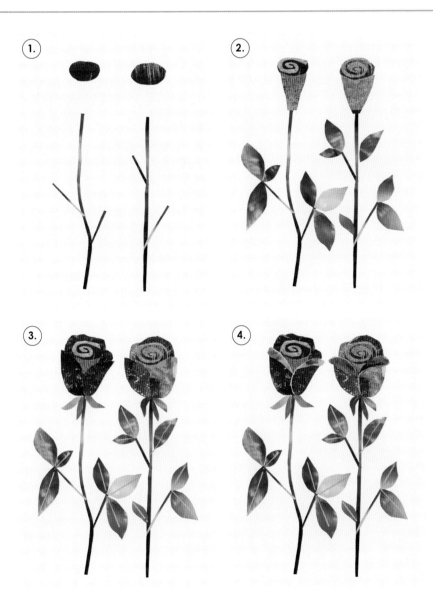

Colors Used:

Found colors: magazine pages

Alternative greens

Tones of red and pink

Step 1: Using the papers that you have found in the magazine, start by cutting two ovals for the tops of the flower heads and the green stems. Arrange on the final surface and adhere in place.

Step 2: Cut and shape some leaves in different sizes from various tones of green taken from the selected magazine pages. Arrange them on the stems. Choose a lighter pink and cut out a spiral and the lower part of the flower head. Position and glue everything in place.

Step 3: Taking a lighter green, cut out some thin strips to add detail to the leaves. Choose a darker shade of pink to create the petals that go around the flower heads, position them, and adhere to the rest of the collage.

Step 4: With a white pen or a fine brush and some white paint, add a few definition lines to the petals and top leaves to help them stand out.

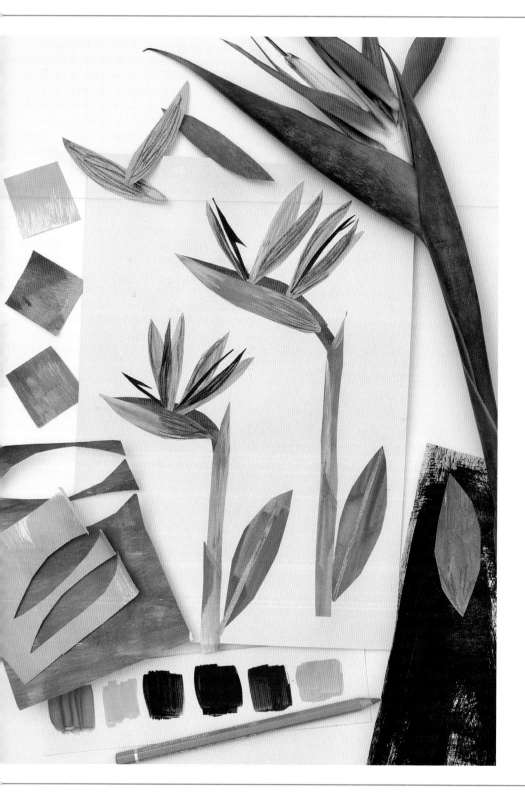

Bird-of-Paradise

Otherwise known as *Strelitzia reginae*, the bird-of-paradise flower is an exotic evergreen perennial that is native to South Africa. The bright architectural flora attracts sunbirds to pollinate them. This exotic-looking plant is the floral emblem of Los Angeles and needs a sunny, mild climate to survive outdoors.

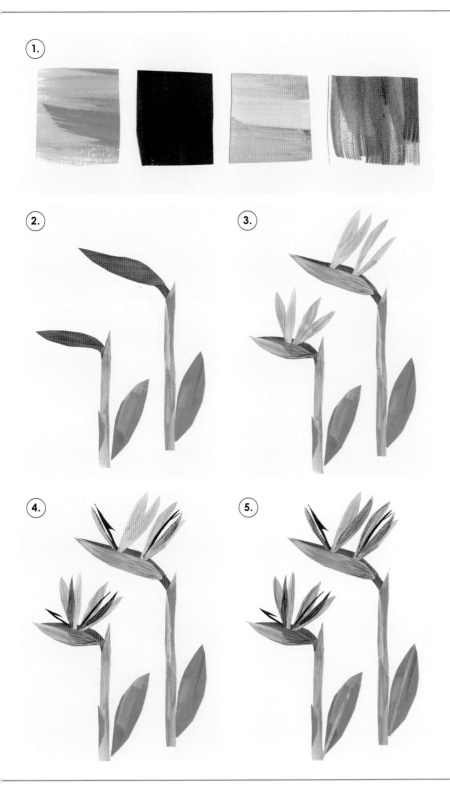

Colors Used:

Hansa Yellow Medium

Flame Orange

Flame Red

Permanent Violet Dark

Light Green

Emerald Green

Step 1: Mix the coordinating colors and prepare the background papers with different tones and textures inspired by the bird-of-paradise flower. For this image, I used cartridge paper, which gives you more solid, vivid colors.

Step 2: Cut out the two lengths from the prepared green paper for each of the stems, as well as the leaves. From the prepared orange sheet, cut out the shape for the base of the flower. You can add some more texture with colored pencil to the green areas to create more depth. Position the pieces on the final surface and glue in place.

Step 3: From the remaining green, cut out the modified leaf that encases the flower head. From the yellow paper, cut out the tepals and place on the collage. Add some extra texture with colored pencil to make the petals stand out more.

Step 4: Finally, cut some very fine strips from the violet paper to create the delicate purple petals.

Step 5: Add some lighter strips on the leaves to add detail and use red and orange colored pencils to add more definition on the tepals to complete the artwork. Glue everything in place.

Cactus

The cactus is part of the Cactaceae family, of which there are 1,750 known species. They enjoy hot, dry, sunny conditions and thrive in desert soils. Cacti have no leaves and are normally covered in sharp, pointy spines, but they often have amazing flowers that may not bloom until they are mature, which can take up to thirty years; the conditions in which they are kept also plays a big part. They are native to the Americas but can now be found in many parts of the world.

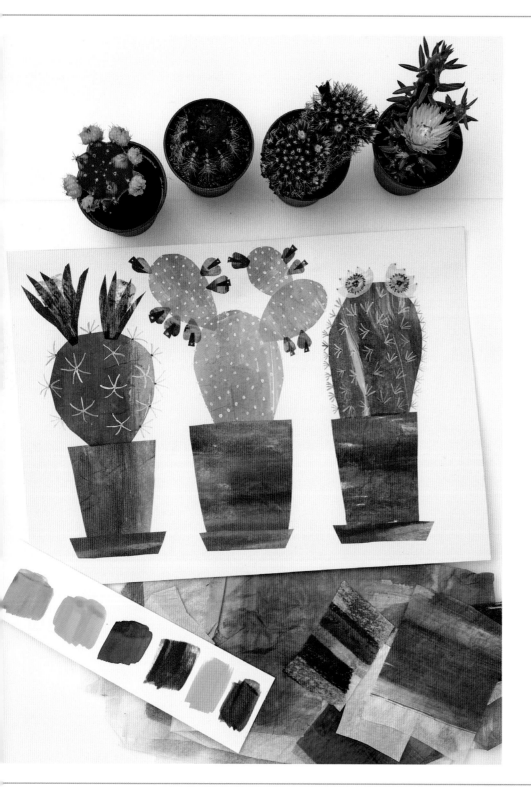

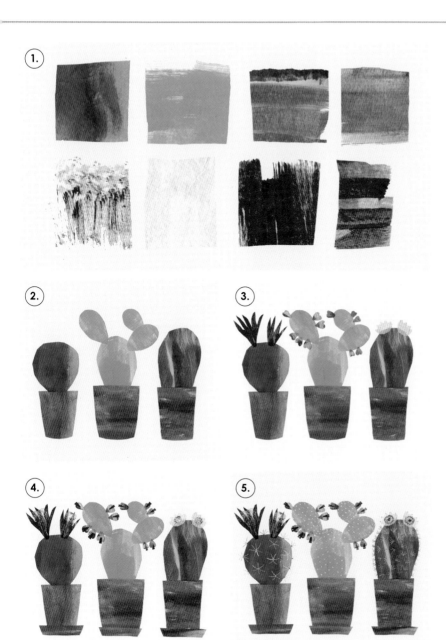

Colors Used:

Emerald Green

Light Green

Turquoise

Process Magenta

Diarylide Yellow

Burnt Sienna

Titanium White

Step 1: Create textured papers with the coordinating paints, taking inspiration from the cacti, flora, and flowerpots. Use the drybrush technique to produce papers for the flowers.

Step 2: Using the prepared papers, cut out the shapes for the flowerpots and the body of the cacti. Position them on the final surface and glue in place.

Step 3: Cut out the different flower shapes and adhere to the cacti bodies.

Step 4: Add some tiny details to the flowers using the textured paper. Cut and add a base to the bottom of the flowerpots. Glue everything in position.

Step 5: Mix some white with a little Burnt Sienna and with a fine brush, add the spines to the cacti plants to finalize the artwork.

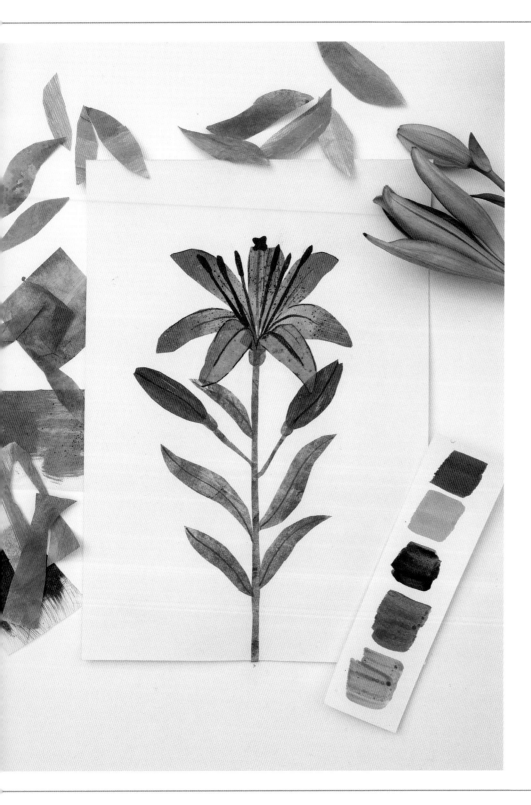

Calla Lily

The lily is a perennial plant that grows from a bulb and has a large prominent flower. The grand flower comes in various colors and normally has a strong fragrance. There are many different species, which originate from many countries, some preferring cooler climates and others, like the tropical lily, which can survive in partial shade in warm sun. They make very popular cut flowers, as they last for up to two weeks if the water is refreshed frequently.

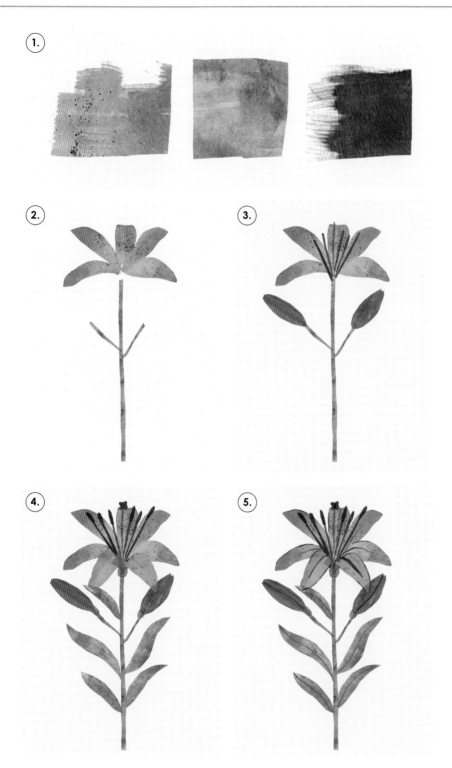

(1.)

(2.)

(3.)

(4.)

(5.)

Colors Used:

Pyrrole Orange

Diarylide Yellow

Sepia

Permanent Green Light

Green Gold

Step 1: Prepare the background papers from the mixed colors; add some splattered textures on the orange with a dry brush, as well as some streaks of green.

Step 2: From the prepared paper, cut a stem and six petals. Arrange on the final surface and glue in position.

Step 3: Create two buds and place on the stem. Cut some narrow strips to form the style and filaments and adhere everything in place.

Step 4: Cut and arrange some leaves on the stem. Then, create the shapes for the stigma and anther, place on top of the filaments, and glue them to the collage. Attach the final petals to the front of the flower and a detail to the top of the stem.

Step 5: Using a thin brush or fine-liner pen, add some definition to the petals and the center of the leaves to enhance the shape and depth of the final image.

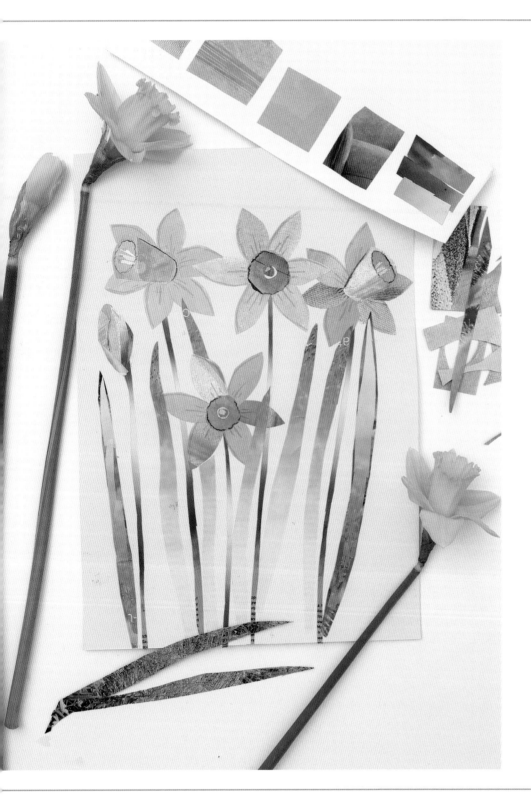

Daffodil

The daffodil, or *Narcissus*, is a full, hardy, spring perennial plant that grows from a bulb. There are at least twenty-five different species of daffodil, with up to 13,000 hybrids. The flowers have striking yellow petals with a trumpet-shaped center. Daffodil bulbs are poisonous to squirrels and dogs. Commonly found in the woods and grasslands of Western Europe, they are the national flower of Wales and the symbol for many cancer charities worldwide.

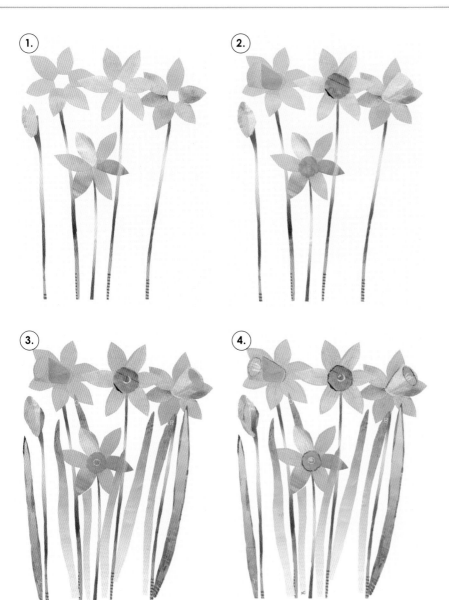

1.

2.

3.

4.

Found colors: magazine pages

Warm Yellows

Orange

Olive green

Step 1: Using the papers that you have found in a magazine, cut out the stems and lay them on the preferred final surface. Select different tones of yellow papers, cut out and arrange the outside petals and single bud, and glue everything in place.

Step 2: Chose a slightly darker tone of yellow or orange to create the central trumpet shaped coronas of the flowers. Cut out and adhere in position.

Step 3: From the green papers, cut out some leaves and place them among the flower stems; some can overlap the yellow petals. Using contrasting colors, add center details to the coronas. Make sure everything is stuck in position.

Step 4: Using a fine brush and some orange paint, highlight the flower heads to give them some shape and definition to complete the collage.

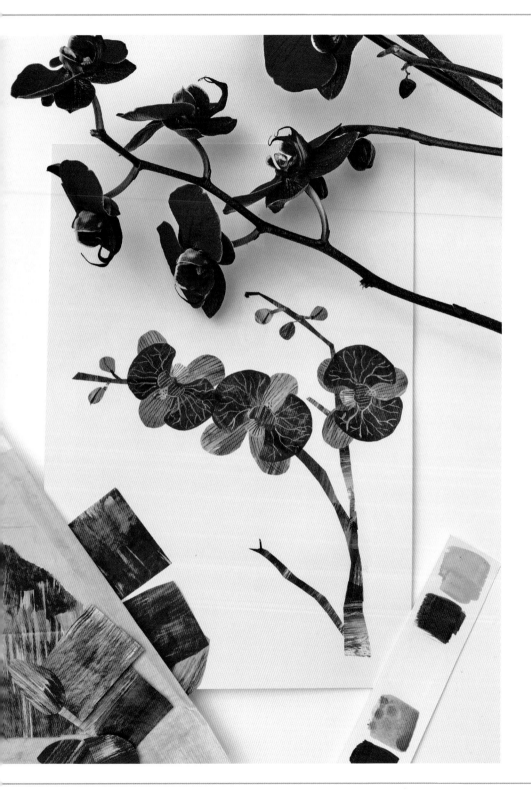

Orchid

The orchid is a diverse and widespread flowering plant that is often associated with perfection, love, beauty, and fertility. Its blooms are often very exotic, colorful, and fragrant. Most orchids grow on trees or rocks, where they feed on plant debris that accumulates around their roots. They need good light, but not strong sunlight, and they thrive in humid, warm conditions. The size, shape, and texture of the leaves depends very much on their habitat and, with over 25,000 documented species, they are by far the largest family of flowers.

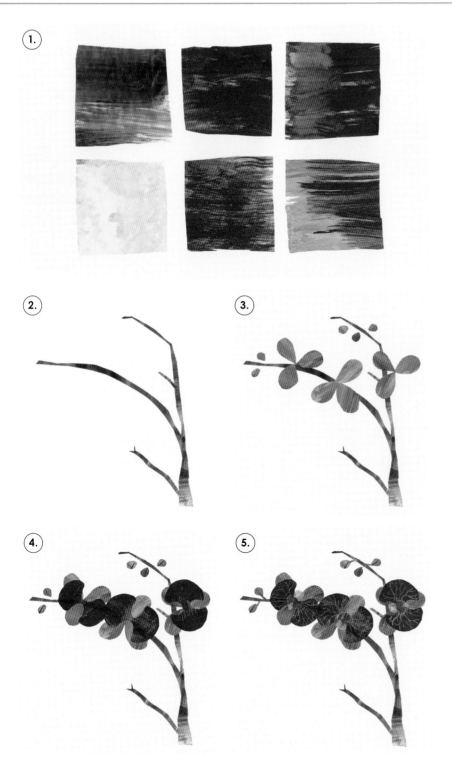

Colors Used:

Quinacridone Magenta

Fluorescent Pink

Naphthol Red Light

Sepia

Brilliant Yellow

Titanium White

Step 1: Prepare the background papers for the orchid by blending light and dark tones together to create textures.

Step 2: From the prepared sepia-colored paper, cut out the stem of the plant and place on the final surface and adhere in position.

Step 3: Next, cut out the initial lower petals, arrange on the stem, and glue in place.

Step 4: Using a contrasting paper color, cut out the next layer of the flower petals. Carefully, position them on the flower heads and glue down.

Step 5: Cut out and arrange the central throat and column of the flower heads and adhere in place. Then, with a thin brush and contrasting colors, add the fine details to finalize the collage.

Peace Lily

The peace lily, or *Spathiphyllum*, is an easy-to-grow, popular houseplant that typically grows wild in the tropical rainforest regions of Central America, where it thrives in shady, wet conditions. They act as great home air purifiers, as they are known to remove small amounts of harmful chemicals from the environment. They thrive best in bright, filtered light but will also survive in low-light situations. Peace lilies should be kept above 60°F (16°C).

1.

Colors Used:

Indigo

Yellow Oxide

Green Gold

Emerald Green

Titan Buff

Titanium White

2.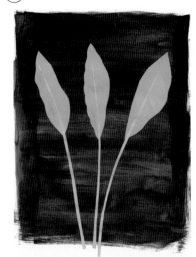

3.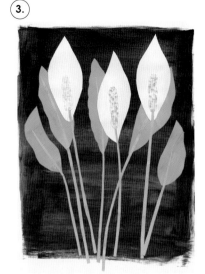

4.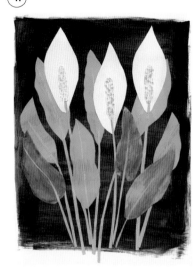

5.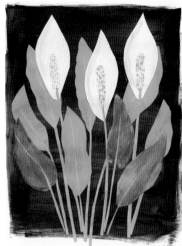

Step 1: Use Indigo or another dark color to paint a background onto the final surface. Using a nontransparent paper for the collage papers, prepare the textures for the plant with Yellow Oxide and Titan Buff; stipple marks with a dry brush that you can use for the spadix (spike of tiny flowers).

Step 2: Cut and place three leaves and stems onto the prepared background and adhere to the final paper.

Step 3: Use some of the uncolored cartridge paper to cut out the shape for the three spathe (leaf-like flowers), cut some more stalks and leaves, and place in position alongside the other leaves. Add the central spadix. Adhere everything in place.

Step 4: Add a few more leaves and stalks to the front of the collage and position and glue down.

Step 5: With a dry brush and a light green color, add a highlight on the spathe to give some depth to the final image.

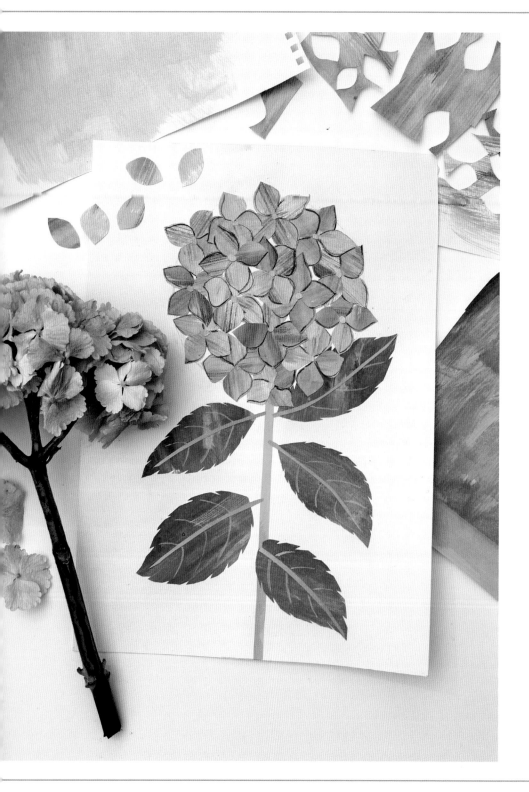

Hydrangea

The *genus* Hydrangea consists of about one hundred species of flowering plants originally native to South and East Asia and North and South America. They produce the main flower cluster from the tips of shoots formed in the previous season. The colors are governed by the amount of aluminum ions in the soil and range from blues and pinks to white. Hydrangeas bloom from early spring to late autumn, providing they are kept well-watered. The blue ones work particularly well as dried flowers and should not be eaten, as they are mildly toxic.

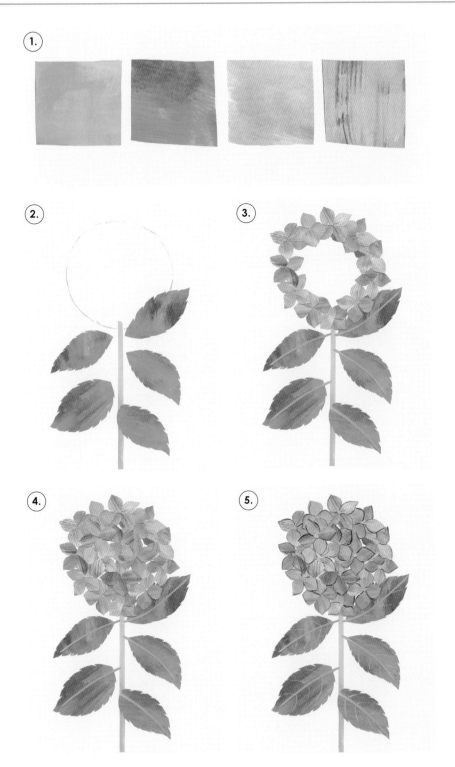

Colors Used:

Process Cyan

Permanent Violet Dark

Permanent Green Light

Light Green

Titanium White

Step 1: To create the collage papers, blend the colors together to achieve soft textures for the flower head, adding some drybrush textures with the dark violet to create the feel of the petals. Mix the green tones to produce some papers for the leaves.

Step 2: On your final surface, sketch out a circle with a pencil so that the flower head is in position. Cut out the leaves and stem and position them below the pencil sketch. Adhere in place.

Step 3: Start by cutting out lots of flower petals, placing them around the outside of the sketched pencil circle, and adhering onto the final paper. Cut out some lighter green strips and create some central veins in the leaves; position and glue everything in place.

Step 4: Cut out some more petals and fill the center of the flower head with more blooms; it is fine to overlap them, as this helps to create more depth.

Step 5: Using the lighter paper that you prepared earlier, cut out some tiny circles to add to the center of each flower. Finally, with a fine brush, add some definition to the flowers and leaves to help them stand out and complete the image.

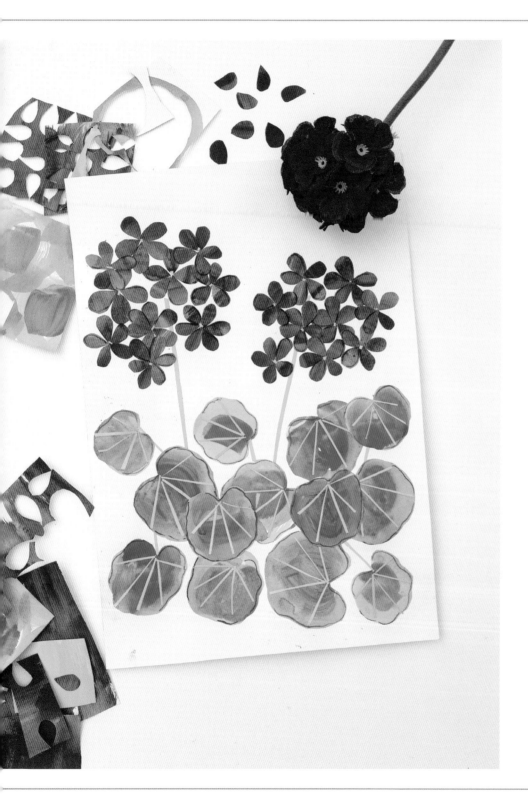

Geranium

The geranium is an herbaceous plant also known as cranesbill. There are over 400 different species and they are widely found in temperate climates, where they thrive in sunny locations with humus-rich soil. They are easy to grow and require little water, but their survival during winter depends on the climate, as their roots can easily become waterlogged and rot away. Geraniums grow in a variety of colors, from red, white, and pink to blue and purple, and they range from trailing to upright varieties. One type of geranium, *Pelargonium Citrosum*, smells like citronella and can be used to keep mosquitos away.

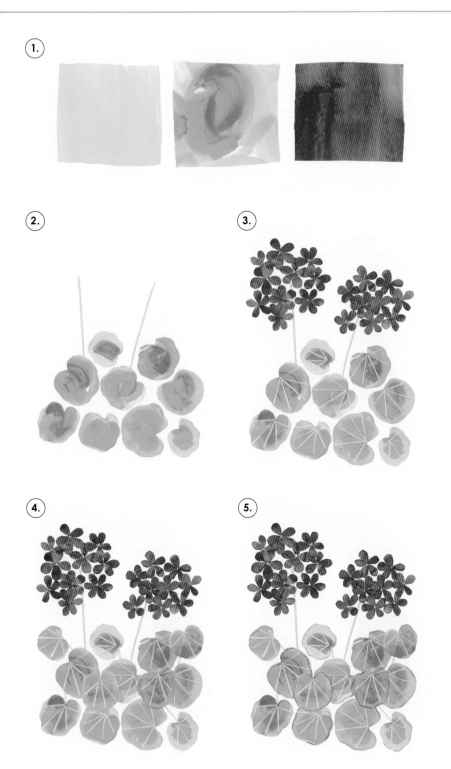

Colors Used:

Fluorescent Pink

Naphthol Red Light

Process Magenta

Hansa Yellow Medium

Emerald Green

Light Green

Step 1: Blend the pinks and reds together and create the collage papers for the flowers. Incorporate the two greens together to produce papers that will be suitable for the leaves.

Step 2: Cut and arrange some leaves and stems on the lower part of the final surface and adhere in place.

Step 3: With a lighter green, cut some strips and add veins to the leaves. Use the prepared pink paper to cut out lots of petals and arrange them in clusters on the flower stalks. Glue everything in position.

Step 4: Cut out and add some more leaves to the arrangement and then, with the light green, cut some more strips and tiny dots to add details to the geranium leaves and flowers.

Step 5: With a thin brush or a fine-liner pen, add some lines to give definition and complete the collage.

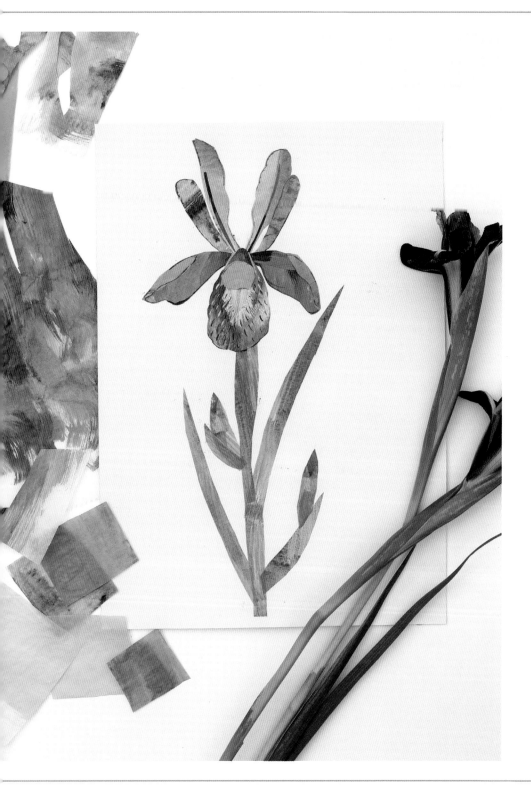

Iris

There are 250 to 300 species of irises, and they take their name from the Greek word for "rainbow." The iris is a hardy perennial plant that grows from a rhizome; they are native to temperate parts of Asia and Europe. It is also the state flower of Tennessee. The exotic-looking flowers bloom in many colors during the spring and summer months. They attract many insects, which in turn help pollinate many flowers.

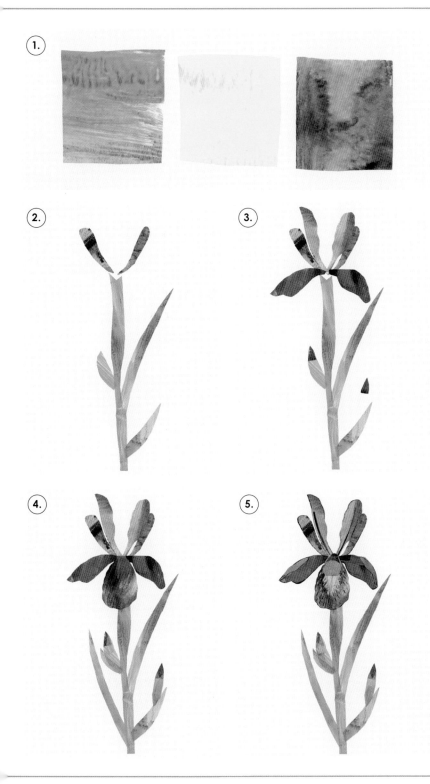

Green Gold

Permanent Green Light

Light Green

Hansa Yellow Medium

Phthalocyanine Blue

Permanent Violet Dark

Titanium White

Step 1: Using the violet, blue, and white paints, create some textured background paper for the flower head. Use the coordinating greens to prepare papers for the leaves and stem.

Step 2: For the stem and leaves, cut the shapes from the prepared green papers and place on the final surface. Cut and arrange two petals for the flower head. Glue everything in place.

Step 3: Using a darker tone of violet, cut and position the two side petals, as well as two buds and back petals. Place on the final surface and glue everything in place.

Step 4: Cut out the final green leaf from the prepared papers to complete the buds. Using one of the textured pieces of violet, cut out the front sepal, place on the collage, and glue all the pieces down.

Step 5: With a fine brush and some white paint, add some texture on the front sepal and cut out a yellow beard to position over this area. Then, cut and place a lighter petal on top. Finally, with the fine brush and the violet paint, add any other details needed to finalize the collage.

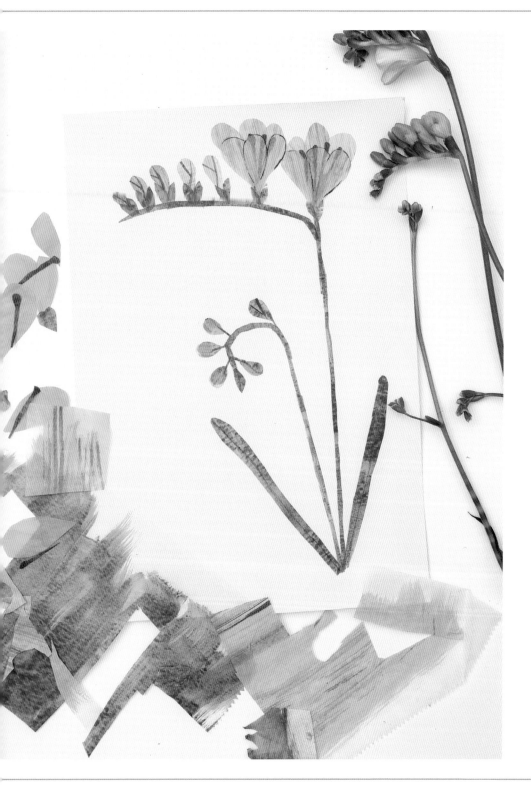

Freesia

Freesia is a genus of about fourteen species, all of which are native to Africa. They have a very strong fragrance, and the brighter the color, the stronger the scent. This perennial flower blooms in spring, at temperatures below 69°F (21°C). These brightly colored, highly scented flowers attract bees, which are in turn responsible for their pollination. They are named after nineteenth-century German botanist and doctor Friedrich Freese, who studied these plants. Freesias are supposed to symbolize innocence, friendship, and thoughtfulness.

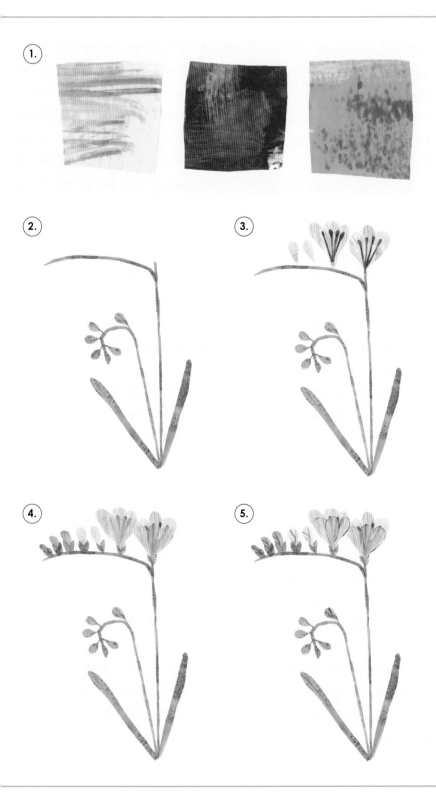

1.

Colors Used:

Permanent Green Light

Green Gold

Naphthol Red Light

Process Magenta

Hansa Yellow Light

Brilliant Yellow

Step 1: Prepare the collage papers for the freesia. Combining contrasting colors with drybrush strokes will help create textures inspired by the flowers.

Step 2: From the prepared green textured paper, cut out the leaves, stem, and buds of the freesia. Position and adhere to the final surface.

Step 3: Cut out the petals and stamens and place on the top of the stalk and then cut out some small yellow pieces to create the buds. Arrange and glue in position.

Step 4: From the yellow textured paper, cut out the front petals of the flower and from the lighter green, create some small buds. Finish the lower part of the flowers with some small green leaves. Glue them all down.

Step 5: With a fine brush or pen, add the finishing touches to define the buds and front flower petals.

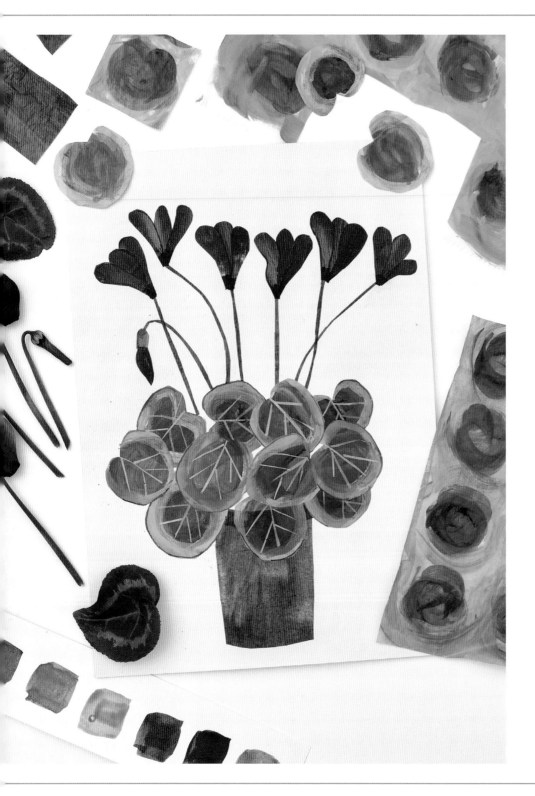

Cyclamen

The cyclamen is a perennial native to Europe, North Africa, and West Asia. It grows from a tuber and is hardy, so it can tolerate cold climates. This plant is often found in shady woody or rocky areas, but also does well as a houseplant and is often grown in pots. It normally goes dormant in the summer and the leaves die down, but they should resprout again in late fall or early spring, depending on the climate. There are twenty different species of cyclamen, and the flowers come in shades of magenta, white, or purple. This plant is toxic to cats and dogs, and it is rumored that in the sixteenth century it was used to induce labor.

1.

2.

3.

4.

5.

Colors Used:

Titanium White

Quinacridone Magenta

Permanent Violet Dark

Burnt Sienna

Green Gold

Permanent Green Light

Turquoise

Step 1: Blend the magenta paint with a little white to create collage papers. To prepare the papers for the leaves, create darker centers with the green to represent the pattern on the individual leaves. Use the Burnt Sienna for the pots and the stems of the cyclamen.

Step 2: First, cut out the shape of the pot and position it on the chosen background paper. Adhere in place. Then, cut out some of the leaves and stems, arrange in the correct position, and glue them all down.

Step 3: Cut out the petals for the flowers. Add a dash of Dark Violet on each tip of the cut petals with a dry brush.

Step 4: Glue down the petals and cut some thin strips of lighter green and use them to add detail to the leaves. Cut out two lighter leaves from the second sheet of prepared paper. Place on top of the darker leaves and adhere.

Step 5: Cut and prepare some more leaves and glue them to the collage. Prepare some extra-thin strips to create detail on the new leaves. Add some final highlights with a thin brush and darker paint on the flowers and leaves to create the finishing touches.

Muscari

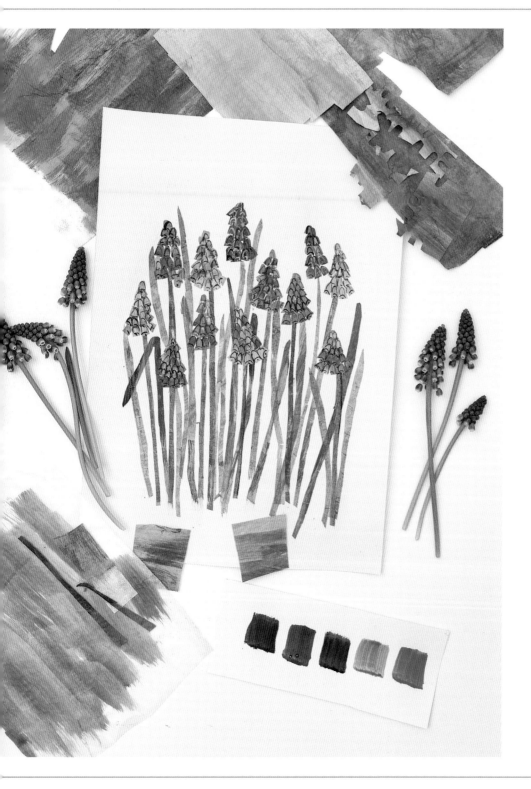

Muscari, more commonly known as grape hyacinths, are a perennial spring flowering bulb originally native to Eurasia, belonging to the lily family. They are extremely hardy and easy to grow. Muscari produce clusters of tiny grapelike florets in different tones of blue, purple, and white. They work well as both a cut and dried flower. They are often planted to attract bees to the garden in early spring, as they have a strong scent, hence its name, which means musk in Greek.

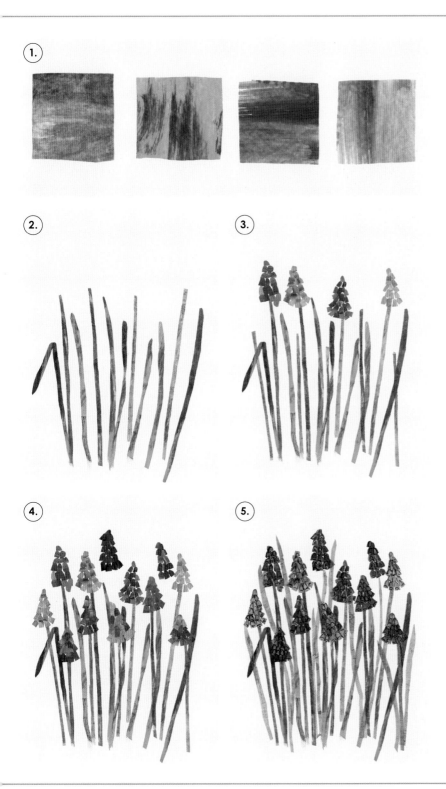

Colors Used:

Emerald Green

Green Gold

Turquoise

Cerulean

Ultramarine Blue

Titanium White

Step 1: Blend the blues and a little white paint together to create some collage papers inspired by the muscari flowers. Use the drybrush technique to create some of the textures. Loosely blend the greens to create collage papers for the leaves.

Step 2: From the prepared green papers, cut out the leaves and stems and arrange on the chosen background surface. Adhere in place.

Step 3: To prepare the flowers, cut out tiny bell shapes from the blue papers. Arrange them on four of the stems and carefully glue them down.

Step 4: Continue cutting out tiny bell shapes for the flowers; try to use the different tones of blue paper that you prepared to give some variety to each flower head. Arrange in place and glue down.

Step 5: From the green paper, cut and add a few more leaves. Add some finishing touches using the ultramarine paint and a fine brush to give the flowers some definition and complete the collage.

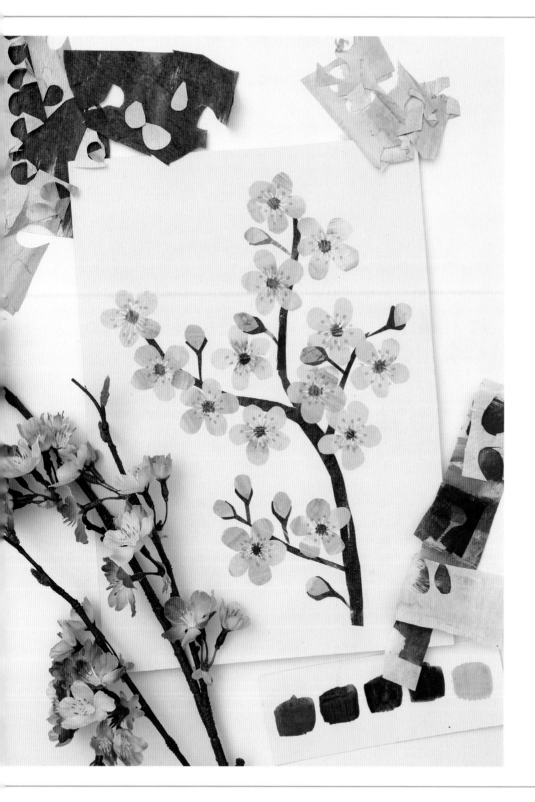

Cherry Blossom

Cherry blossom, or sakura as it is known in Japan, is the flower of several trees in the genus *Prunus* (plum, cherry, peach, apricot, and almond). These trees are found mainly in temperate areas of the Northern Hemisphere. Cherry blossom is considered the national flower of Japan. The beautiful pale flora is not only a symbol of spring, but also of renewal and hope. Every year, the Japanese carry out the centuries-old custom called *hanami*, which means "flower viewing." It has now become a great excuse to picnic or hold parties outside under the trees. Many of the varieties have now been cultivated for ornamental use and so do not produce fruit. They generally flower from March until April, depending on the climate of the region, and the blossoms last around a week.

1.

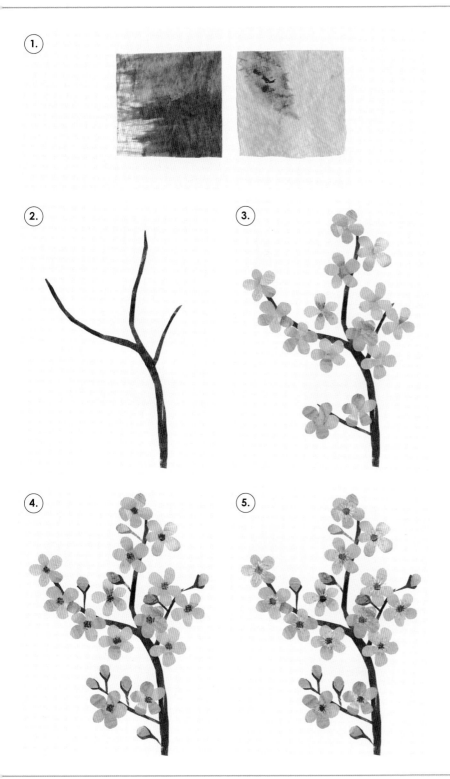

2.

3.

4.

5.

Colors Used:

Naphthol Red Light

Quinacridone Magenta

Sepia

Burnt Sienna

Diarylide Yellow

Titanium White

Step 1: Loosely blend the red and magenta paints with white to create the collage paper for the flowers. Similarly, blend the Sepia and Burnt Sienna and use the drybrush technique to create papers inspired by the branches of the blossom.

Step 2: Carefully, cut out the shape for the branch of the cherry blossom tree and arrange it on the final surface. Glue in place.

Step 3: From the prepared pink papers, cut out the petals for the blossoms, arrange them on the branches, and adhere in position.

Step 4: Cut out some small stalks and buds, arrange them on the branches, and glue down. Then, with a dry brush, carefully stipple the center of each bloom with a darker pink tone.

Step 5: Using some white paint and a fine brush or a white fine-liner pen, draw in the filaments of the flowers. For the final touch, add some dots of yellow to create the anthers on each blossom.

Succulents

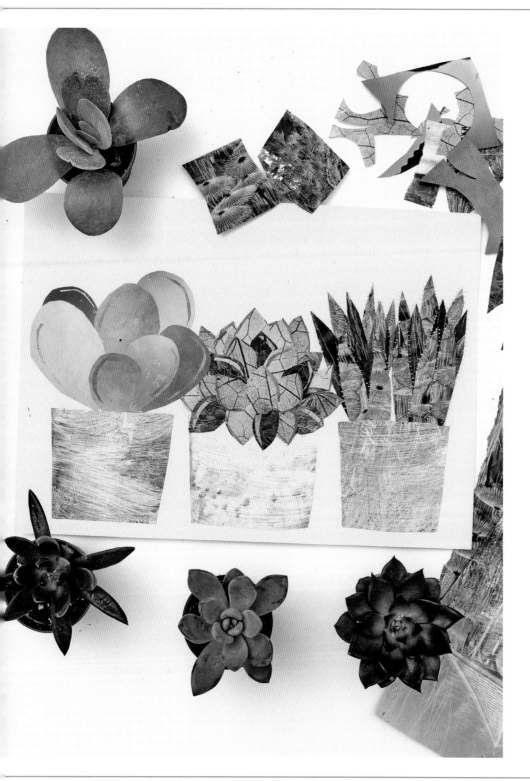

Succulents are often referred to as desert plants and are known as plants that store water. They therefore manage to exist in dry, harsh conditions; their name comes from the Latin word *sucus*, meaning "juice" or "sap." Amazingly, there are approximately sixty different plant families containing succulents, and they come in many different colors, ranging from greens and blues to purples and pinks. They are generally pest-resistant and very easy to maintain.

Colors Used:

Found colors (magazine pages): tones of greens, turquoise, and gray

Olive Green

Titanium White

Step 1: From the gray found paper, cut out three planters. Using the white paint and the drybrush technique, roughly apply some paint to the pot shapes. Arrange on the final surface and adhere in place.

Step 2: Cut out the leaf shapes for the different succulents. Arrange them in position above the planters. Glue in place.

Step 3: Continue adding leaves to the different plants. Use different tones of green to make the leaves stand out and to build definition.

Step 4: Carefully, cut out some thin strips in lighter and darker tones that you can use to highlight the succulents. Place them on the edges of the leaves and adhere. Mix a little light green paint and add any extra details with a fine brush.

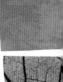
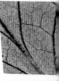
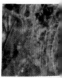

Hyacinth

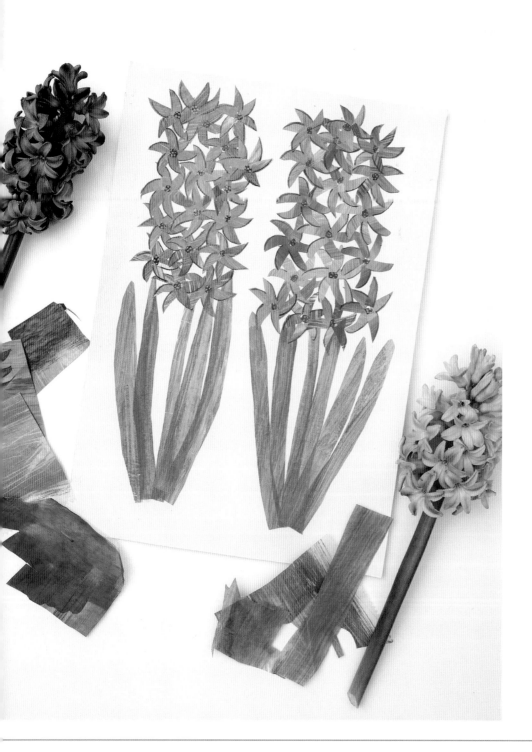

Hyacinths are spring bulbs with a highly fragrant flower that blooms in dense clusters. "Hyacinth" is the common name for approximately thirty perennial flowering plants of the *Hyacinthus* genus, originally found in the Mediterranean region and Africa. They have been cultivated commercially since the sixteenth century, when they were reintroduced to Europe from Turkey and Iran. The bulb should be planted in fall before any sign of a hard frost, and then you can expect it to flower in March or April. They come in many colors, ranging from deep purple to magenta, white, and even yellow. Hyacinths can also be used as cut flowers in a mixed bouquet.

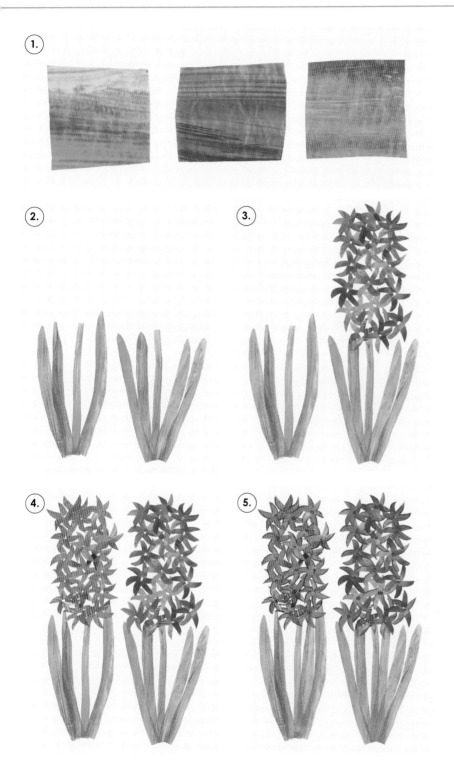

Colors Used:

Ultramarine Blue

Emerald Green

Green Gold

Process Magenta

Diarylide Yellow

Titanium White

Step 1: Blend the magenta and white paint to create collage papers. Do the same with the Ultramarine Blue and white and the two greens, using the drybrush technique with the darker hue to create some tonal difference. Also create two small areas of pure Ultramarine Blue and Process Magenta to use for the centers of the flower heads.

Step 2: Using the prepared green paper, cut out the shapes to create the leaves and the stems of the hyacinth. Position on the final paper and adhere.

Step 3: Take the blue paper and cut out lots of blue petal shapes to create the flower head. Arrange them in groups of six to create the individual flowers. Glue in place as you go to keep them from moving around.

Step 4: Do the same with the pink paper to create the other flower head. Adhere in place.

Step 5: Using the darker pieces of paper that you created, cut out tiny circles to use for the centers of each flower head. Glue them down as you go. Once they are dry, add some tiny yellow dots with a fine brush. Add some definition to the flowers with the ultramarine and magenta to complete the collage.

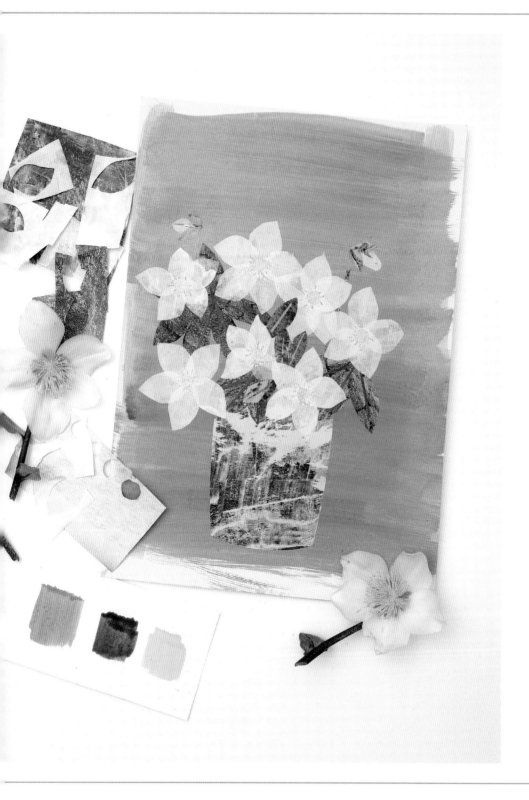

Hellebores

The hellebore, or winter rose, is a perennial garden plant that loves shady areas and fertile, well-drained soil. They originate from Europe and western China and produce white, speckled pink, or even black flowers from winter to early spring. Their flowers are a rich source of nectar, so they can attract various types of insects throughout the spring months. In the past, hellebores were often used as an herbal remedy, due to their high content of toxic substances. Historians believe that it was included in the herbal mixture that is said to have attributed to the death of Alexander the Great.

1.

Colors Used:

Found colors (magazine pages): textured dark and tones of greens and yellows

Hansa Yellow Medium

Shading Gray

Titanium White

2.

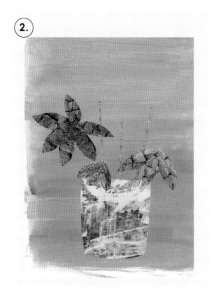

3.

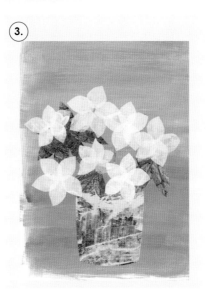

Step 1: Paint some white collage paper to use for the flower petals. With a wide brush, paint the background paper with a shade of gray.

Step 2: Using the found textured dark paper, cut out the shape for the planter and position it on the painted gray background. Then, cut out three stems and some of the leaves, arrange them above the positioned planter, and adhere all of them in place.

Step 3: Cut some thin strips of darker green and create some veins for the leaves. Adhere in place. Then, from the white prepared paper, cut out five petals for each flower head. Position the flowers on top of the leaves and stems and glue in place.

4.

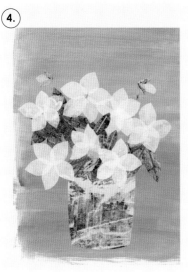

5.

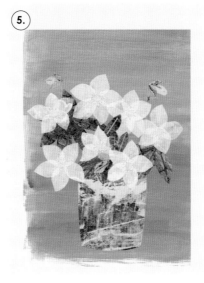

Step 4: Add a few more small leaves around the flower heads and create a couple of buds from the lighter green found paper. Position and adhere to the collage.

Step 5: From the yellow found paper, cut some small circles that you can use for the center of the flower heads. Position them and glue in place. With a fine brush or fine-liner pen, add some detail around the centers of the flowers to add definition and complete the collage.

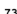

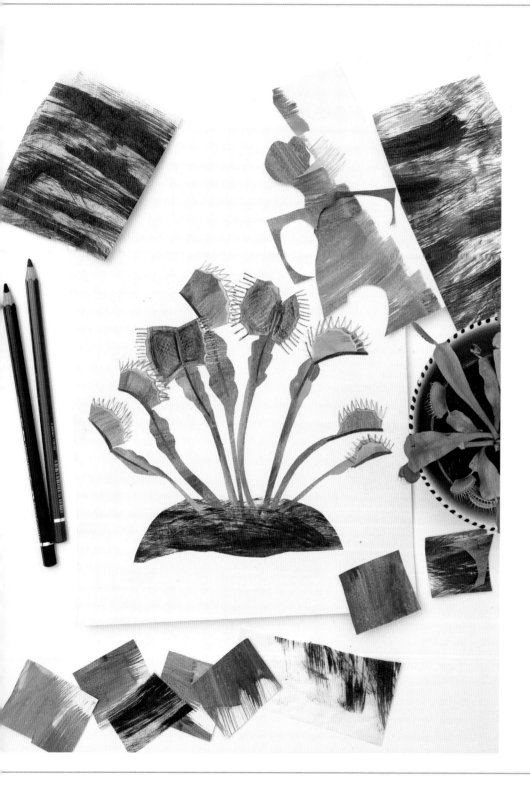

Venus Flytrap

The Venus flytrap, or *Dionaea muscipula*, is a carnivorous perennial plant that was originally found growing only in North and South Carolina in the United States; it has now been introduced to other states too, including Florida and New Jersey. The species grows in bog-like coastal areas with very high humidity. They depend solely on the nutrients provided by insects and so require very low-quality soil to exist. Each plant has around six stems with hinged leaves; the edges of the leaves are lined with spike-like teeth that snap shut like a trap when triggered by the movement of an insect. It takes around ten days for the plant to completely digest the insect and reopen its trap.

Colors Used:

Sepia

Burnt Sienna

Olive Green

Light Green

Step 1: Loosely mix the Burnt Sienna and Sepia paint and create some textured paper that resembles the soil. Similarly, blend the two greens to produce a paper suitable for the leaves and stems. Colored pencils can be used to add texture to the centers of the hinged leaves.

Step 2: Using the prepared textured brown paper, cut out a shape for the soil. Place on the final surface and adhere. Cut out the stems and the first leaves from the green paper and position on top of the soil. Glue down and then add some pencil texture to the inside of two of the leaves to create some depth.

Step 3: Cut out the shapes for the other leaves and add some pencil texture to the ones that will remain open. Place them on the top of the stems and glue down.

Step 4: Now, cut some thin dark green strips and add some detail to the edges of the leaves to create some definition.

Step 5: Using some of the textured pieces of brown paper, cut shapes for the open leaves and place on top of the stems. Then, using a thin brush or a fine-liner pen, create the teeth around the edges of the leaves to complete the collage.

Bluebell

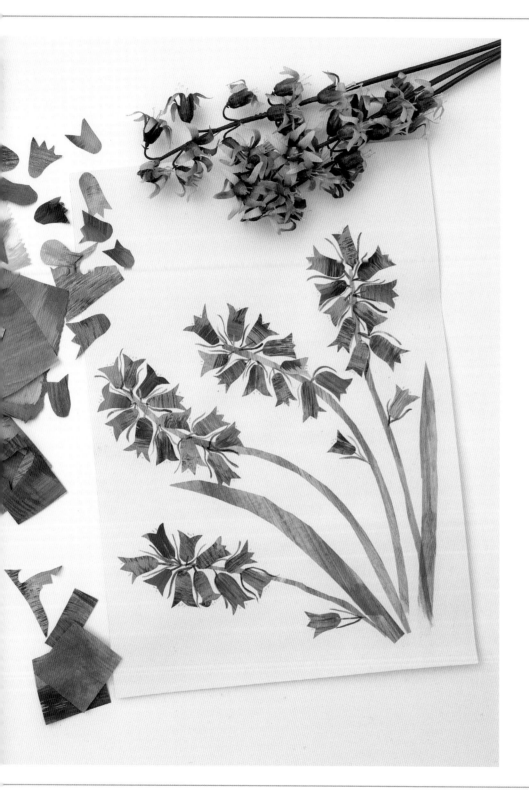

Bluebells are perennial bulbous herbs that emerge and flower from April onward. They are a protected species and are widely found in British woodlands. There is also a Spanish species, *Hyacinthoides hispanica*, which has slightly different color pollen and tends to be a more dominant variety. They can be traced back as long ago as the last ice age. Bluebells are known to be poisonous and contain at least fifteen biologically active compounds to defend themselves against animals and insects. Their properties are now being tested for medical research, in hope that they may be able to help with a cancer cure in the future.

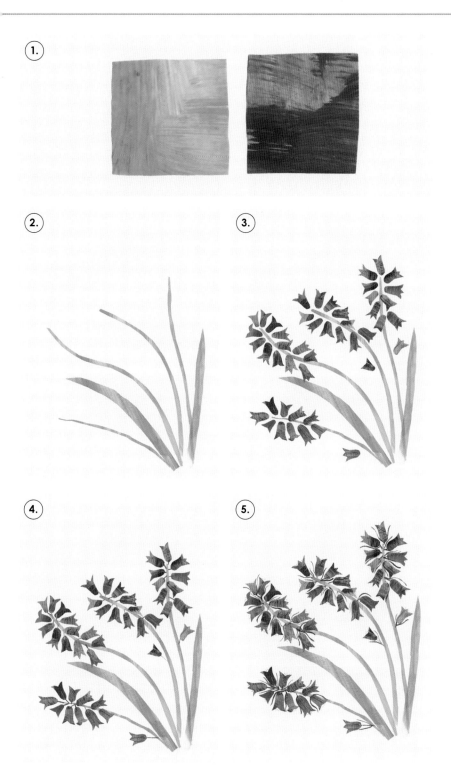

1.

2.

3.

4.

5.

Colors Used:

Ultramarine Blue

Lime Green

Emerald Green

Titanium White

Step 1: Create some collage papers inspired by the bluebells, blending the Ultramarine Blue and white paint together to produce some papers for the flowers and roughly mixing the two green paints together to create the papers for the leaves.

Step 2: Using the prepared green paper, cut out the stalks and leaves, position on the final surface, and adhere in place.

Step 3: From the prepared blue paper, cut out the flower heads and position them along the stalks. Glue in place.

Step 4: Cut some tiny strips to attach the flower heads to the stems, place them on the collage, and glue down.

Step 5: With a thin brush, add some fine details on the flowers with the left-over blue and green paint to complete the collage.

Basil

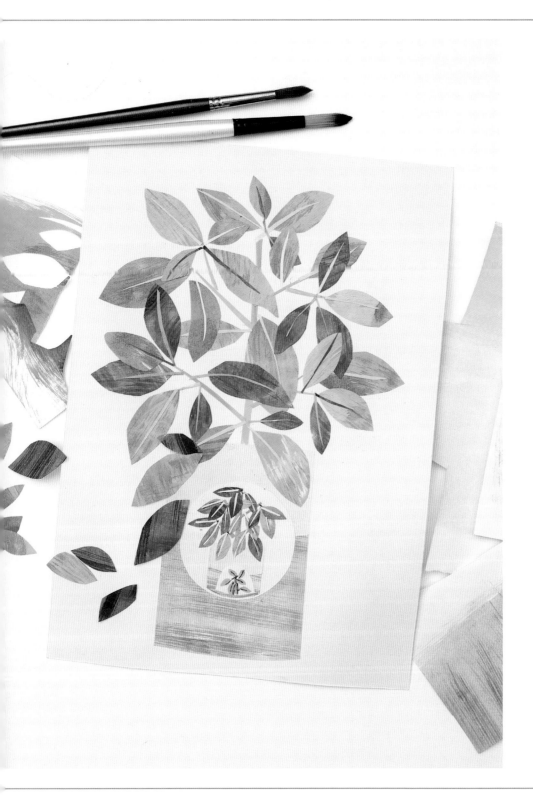

Basil is an annual herb in the mint family. It has been grown for thousands of years in tropical regions, but it is thought to originate from India, where people have used it as a spice and for medicine for at least 5,000 years. It is also a staple ingredient in Italian cuisine, often combined with savory dishes. Basil is not frost hardy and really only thrives well in sunny, warm climates. There are over 160 different varieties of basil that differ in size of leaf, color, and taste. The leaves are edible and are also rich in essential oils; each type of basil has its own unique aroma and flavor. The essential oils from the plant are also used in the pharmaceutical and chemical industries.

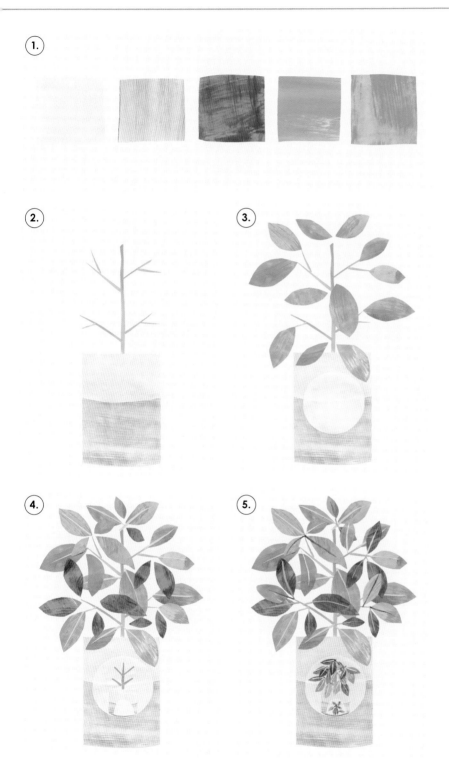

Emerald Green

Light Green

Turquoise

Flame Orange

Titan Buff

Step 1: Prepare the papers for the collage. Blend the greens together to make several different sheets of paper inspired by the leaves and then create the textured paper for the container from the orange and buff pigments.

Step 2: From the prepared papers, cut out the shape for the container and place on the final surface. Using the mid-green paper, cut out the stem and branches for the basil plant. Position and adhere everything in place.

Step 3: Using the same green paper, cut out some leaves in different sizes, position them on the branches, and glue down. Then, cut a white circle for the label and position it on the container.

Step 4: From the lightest green paper, cut thin strips and add them to the glued-down leaves to create detail. Adhere in place. Then, with the darker green paper, cut out some more leaves and arrange them on the plant. Add some detail to the center of the container. Adhere it all in place.

Step 5: To finalize the collage, cut lots of thin strips to add the final details to the leaves. Position them and glue down. Add and glue down some small leaves on the center of the container to complete the image.

Strawberry Plant

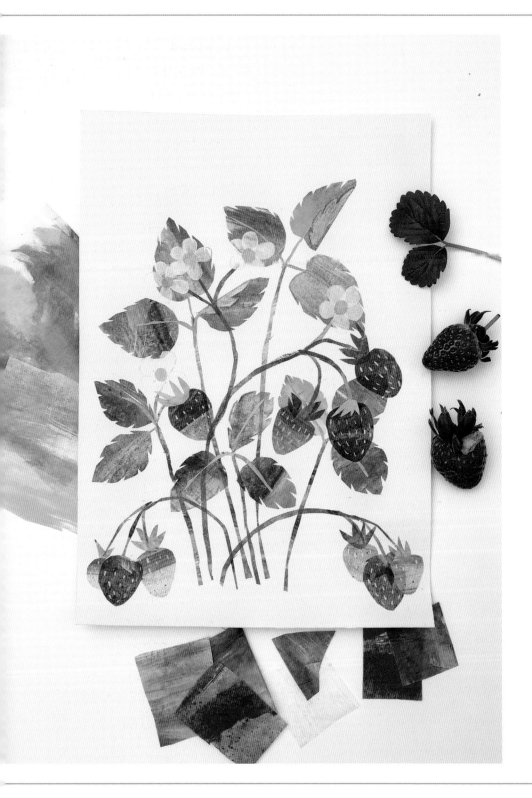

The strawberry plant is a perennial and a member of the rose family, *Rosaceae*. It is thought to date back to the time of ancient Rome. There are over one hundred varieties, which are suitable for different climates and growing conditions. They originated from the temperate regions of the Northern Hemisphere but have adapted over time to grow in many different climates. Raw strawberries were popular among Native Americans, who also used them to prepare strawberry-flavored corn bread. Recent studies show that strawberries can help reduce high blood pressure and inflammations, and that they are a rich source of vitamin C.

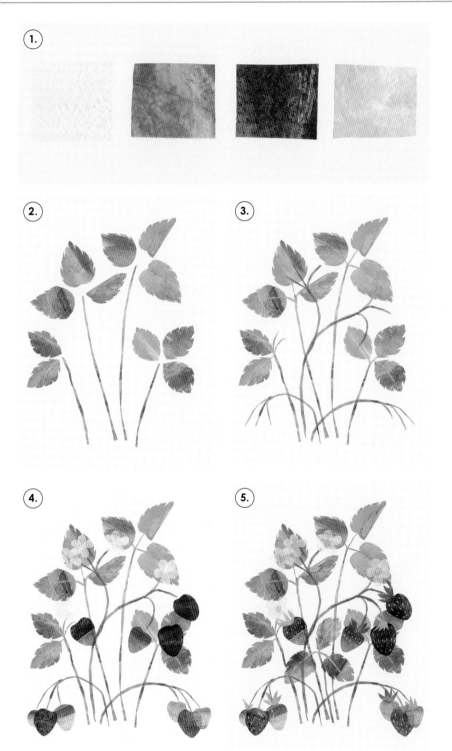

Colors Used:

Quinacridone Red

Naphthol Red Light

Permanent Green Light

Olive Green

Diarylide Yellow

Titanium White

Step 1: Prepare some textured papers inspired by the strawberry plant, loosely mixing the two reds for the strawberries. You can also add texture by flicking a brush loaded with paint over the surface of the red sheets. Blend the greens to prepare the paper for the leaves. Then, create a small sheet of yellow paper and a sheet of white paper for the flowers.

Step 2: Cut out the first stems and leaves and position on the final surface. Adhere in place.

Step 3: Cut out and place some more strips for the stems where the fruit and flowers will be positioned. Add some detail to the leaves. Adhere everything on the final surface.

Step 4: Cut out the strawberry shapes and position them on the stems. Using the white paper, cut out the petals for the flowers, place on the final paper, and adhere everything in position.

Step 5: With a fine brush, add a yellow highlight around the flowers and some flecks on the fruit so that they have some definition. Using the green paper, cut out the leaves for the fruit and position above the strawberries. Adhere in place to finalize the collage.

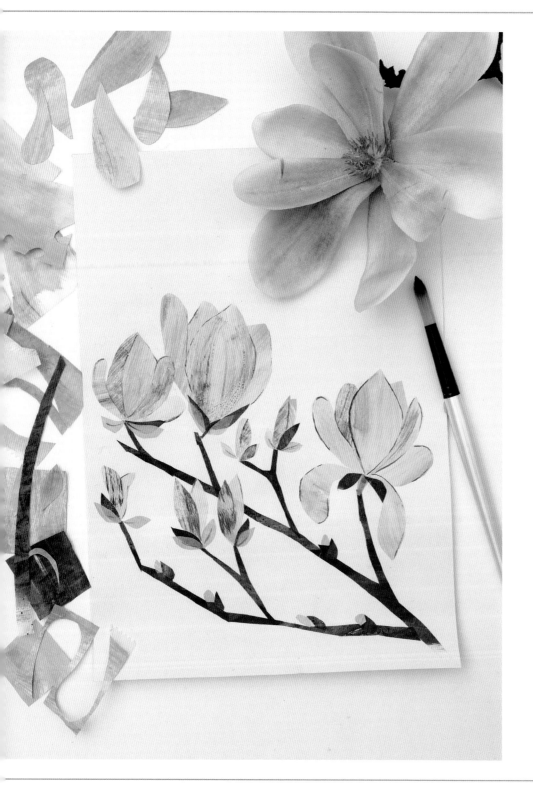

Magnolia

The magnolia tree is part of the genus *Magnolia* that consists of of 210 flowering plants in the Magnoliaceae family. Named after the French botanist Pierre Magnol, they differ greatly in size, shape, color, and type of habitat. The trees can be either evergreen or deciduous. They have been naturalized in almost all corners of the world. The southern magnolia was officially designated as Mississippi's state flower in 1952. They flower in spring and produce pollen, rather than nectar. The flower is typically pollinated by beetles. In traditional Chinese medicine, the bark and flower bud of the *Magnolia officinalis* is thought to help reduce anxiety and reduce tumor growth. The trees can live for over one hundred years.

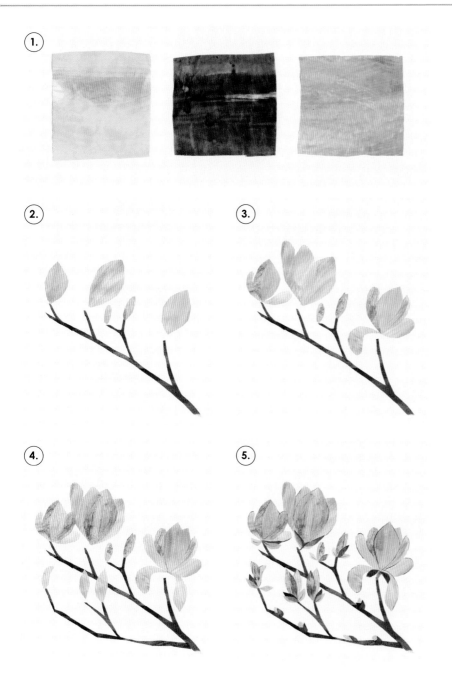

Colors Used:

Quinacridone Magenta

Naphthol Red Light

Green Gold

Sepia

Titanium White

Step 1: Using inspiration from the magnolia branches, prepare the papers for the collage by loosely mixing the red, magenta, and white paints to create different shades of pink texture for the flowers. With the drybrush technique, prepare the collage paper for the branches and use the green gold and white paint to create paper for the leaves.

Step 2: From the prepared papers, cut out the shape for the branch and place on the final surface. Cut out the initial petals, position them on the branch, and adhere everything.

Step 3: Cut out some more petals and add to the flowers already in position. Glue in place.

Step 4: Cut out a lower branch from the prepared sepia paper and add some buds and more petals to the existing flower head. Adhere everything in position.

Step 5: To finalize the collage, cut some sepia and green leaves from the prepared papers and place beneath the flowers. Create some buds on the lower branch. Lastly, with a thin brush or fine-liner pen in a darker tone, add some definition to the flower heads to add depth to the petals.

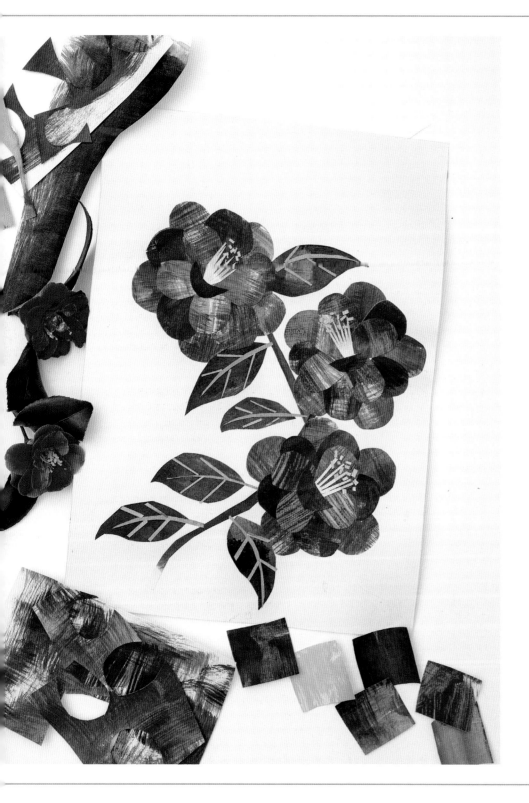

Camellia

Camellia is an evergreen shrub that belongs to the Theaceae family. It is native to Asia and grows well in semi-shaded to full-shade locations. This plant does not survive drought well and prefers cool, moist, well-drained soils. The Japanese camellia is the state flower of Alabama. *Camellia sinensis* leaves are used to make tea. They are often grown at an elevation of over 4,900 feet (1,500 m) because the plant grows much slower and develops much more intense flavor. Tea oil can also be made from camellia seeds, which is very popular as a cooking oil in Southern China. The flowers are large and multicolored and come in many shades ranging from red and pink to yellow and white. Camellias tend to bloom in late winter or early spring.

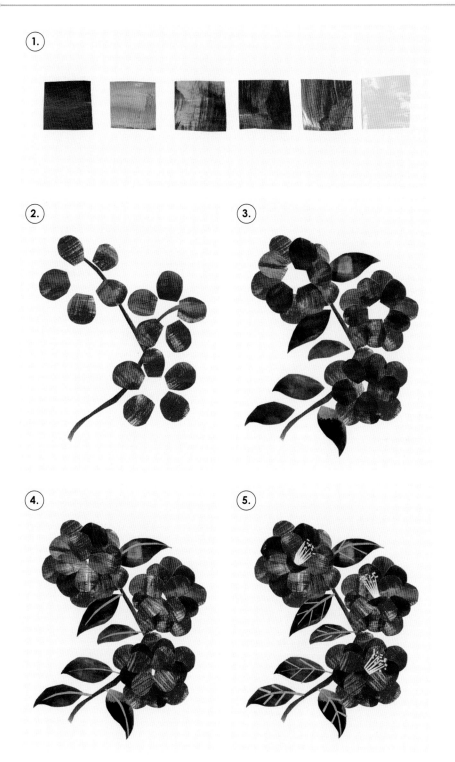

1.

Colors Used:

Diarylide Yellow

Alizarin Crimson

Naphthol Red Light

Process Magenta

Light Green

Teal

Titanium White

2.

3.

4.

5.

Step 1: Prepare the collage papers; loosely blend the pink and red paints together to create different tones and textures. Use the drybrush technique to blend the greens. Create lighter tones by adding white paint. Prepare a small amount of yellow paper for the central details of the flowers.

Step 2: From the darker prepared paper, cut out the branches and place. Adhere to the page and use the textured red and pink papers to cut out the first petals. Arrange them on the branches and glue in position.

Step 3: Cut out some leaves from the green paper and glue in position. Then, from the different tones of red paper, cut out the next set of petals. Position and glue in place.

Step 4: Cut some strips of lighter green and place them on the leaves. Adhere in place. Place some more petals on the flower heads. Glue in position.

Step 5: Place the light green strips on the leaves and adhere. Then, take the yellow prepared paper and cut out the central features, position carefully, and glue in position. Finalize the collage by adhering one last dark red petal over the central anthers.

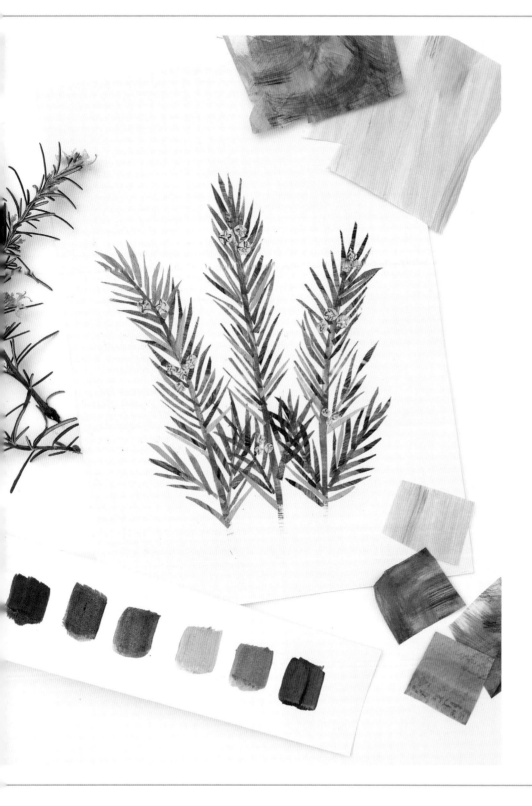

Rosemary

Rosemary is a perennial evergreen plant that is native to the Mediterranean coast and belongs to the Lamiaceae family; it is closely related to mint, lavender, oregano, and basil and has a particularly strong, aromatic aroma. The plant prefers dry sandy soils, with plenty of sunlight. It is mainly cultivated for its aromatic and medicinal properties and is mostly used as a spice, both fresh and dried. In the past, it was often used by folk medicine to treat rheumatism, bruises, and sores. During the sixteenth century, it was used to disinfect rooms. The rosemary plant produces a bluish-purple flower and will flower year-round in warm climates. It is said to be a symbol of love and loyalty, and in some parts of the world, branches of rosemary are worn by the bride, groom, and guests during wedding ceremonies.

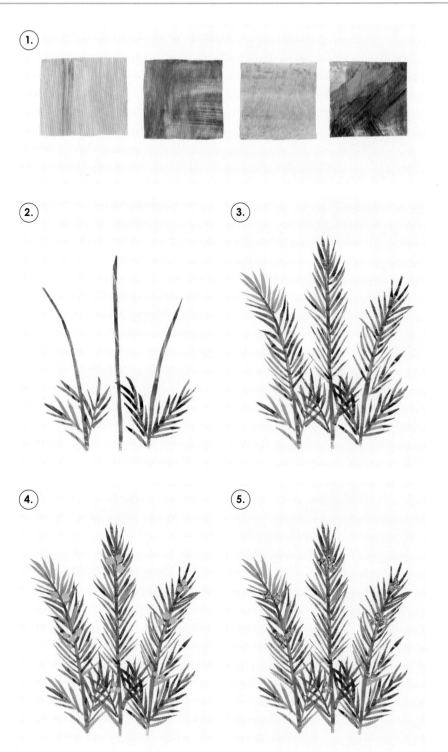

Colors Used:

Ultramarine Blue

Permanent Green Light

Olive Green

Sap Green Hue

Sepia

Permanent Violet Dark

Titanium White

Step 1: Taking inspiration from the plant, blend the green paints together to produce some varying green tonal papers for the needles. Similarly, mix the sepia and white and a touch of olive green to create paper for the stalk. Use the white and violet paints to make a small amount of collage paper for the flowers.

Step 2: From the prepared papers, cut out the long stems and place on the final surface. Glue in place. Using the green papers, start to cut out the fine needles and begin arranging them in position.

Step 3: Continue cutting out needles from the green prepared paper, placing them on the stems, and then adhere everything in position.

Step 4: Cut out some small circles from the prepared violet paper. Place them in different locations on the stems. Also, add some lighter colored needles to create more contrast. Glue everything in place.

Step 5: To finalize the collage, add some details to the flowers with a darker color using a very fine brush.

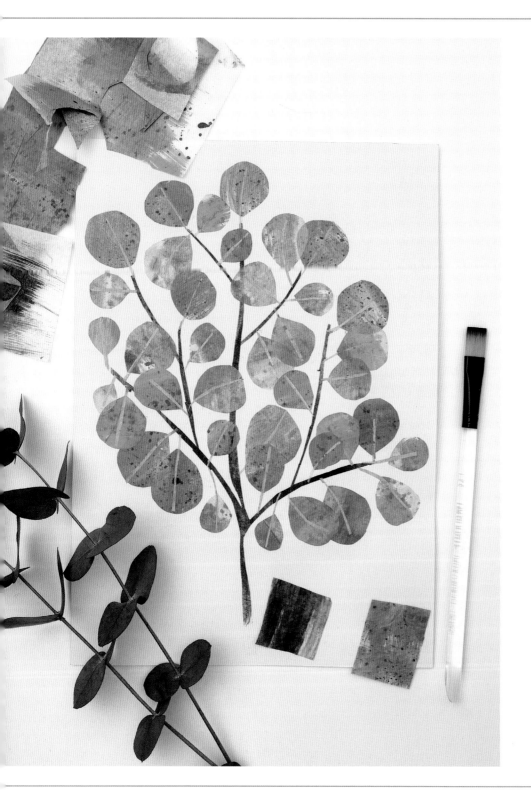

Eucalyptus

There are over 700 species of eucalyptus, which belongs to the Myrtaceae family. Most of the trees are evergreen, and they are originally native to Australia, New Guinea, and Indonesia, although now they are found growing commercially in tropical and subtropical areas worldwide. They are known as one of the tallest trees, reaching as high as 200 feet (61 m), and in the wild, they can easily live for up to 250 years. The trees are grown for their wood and oil; they also absorb huge amounts of moisture, so they can be used to drain marshes and waterlogged land. Most species of eucalyptus shed their bark once a year; the outer layer comes off in long shreds or flakes. The leaves are rich in oil, which is used for medicinal purposes to help improve symptoms of bronchitis, sore throats, and colds.

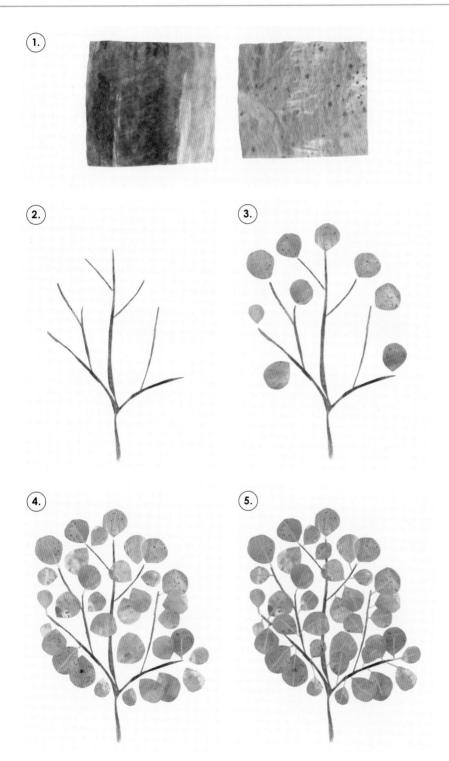

Colors Used:

Teal

Olive Green

Sepia

Shading Gray

Titanium White

Step 1: Blend the colors for the collage papers together, using the teal, olive green, and gray paints to create the texture. Add some paint splats with the sepia to mimic the feel and look of the leaves.

Step 2: From the prepared papers, cut out the branches for the eucalyptus sprig and position on the final surface, adhering in place.

Step 3: Cut out the first few leaf shapes from the prepared green papers and position at the top ends of the branches. Glue in position.

Step 4: Add some thin strips of lighter green to the initial leaves to add stems and detail and then cut out more leaves and place them along the branches. Adhere everything in position.

Step 5: Cut out some thin light green strips to add detail and stems to the remaining leaves. Glue them all down to finalize the collage.

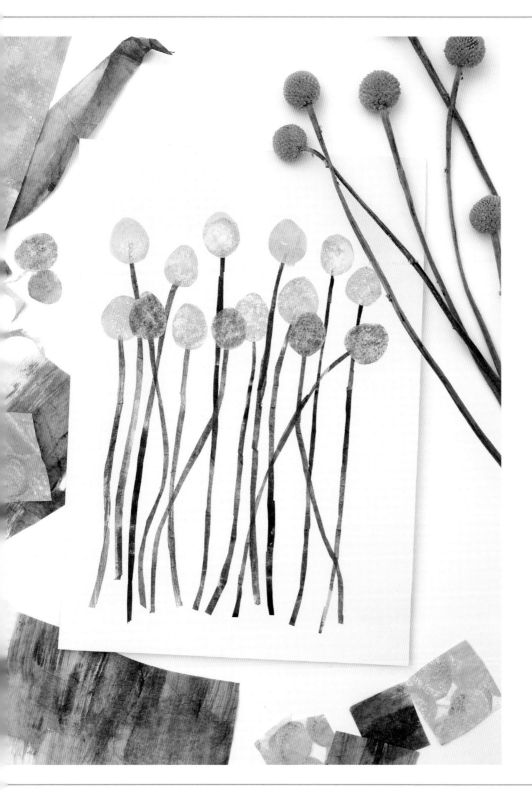

Craspedia

Craspedia are perennial herbs that are often called billy buttons, drumsticks, or woollyheads. They belong to the genus *Craspedia*, which is part of the daisy family, Asteraceae. Craspedia are native to Tasmania, New Zealand, and Australia, where they are found growing wild. They tolerate many different soil types, climates, and terrains, from coastal to alpine habitats, which makes them extremely hardy. They have now been cultivated as a garden flower and have also become increasingly popular with florists as part of wedding bouquets or dried flower arrangements.

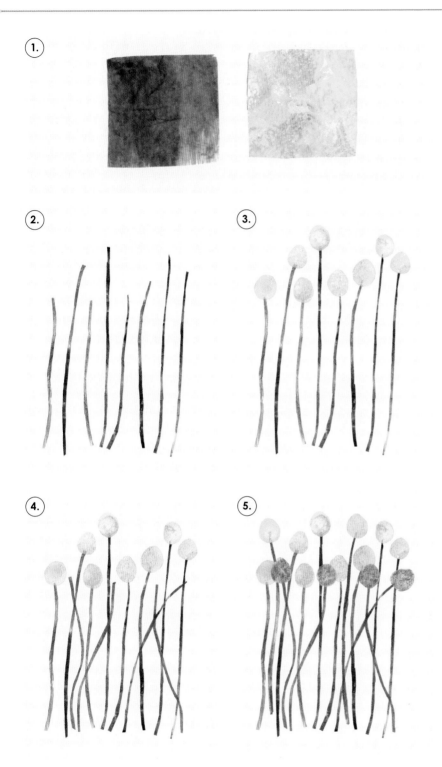

Colors Used:

Sepia

Green Gold

Hansa Yellow Medium

Titanium White

Step 1: Use the chosen colors to create some textured sheets of paper suitable for the craspedia flower heads. Use the sepia and green gold paint to create some collage papers for the stalks.

Step 2: Using the prepared sepia paper, cut out the stalks for the craspedia. Arrange on the preferred final paper and adhere in place.

Step 3: Cut out the spherical shapes for the flower heads from the textured yellow collage paper. Place on the tops of the stalks and glue down.

Step 4: Cut out some more stalks and arrange them on top of the existing collage. Adhere in place.

Step 5: Finally, to complete the collage, cut out some more spherical flower heads in a slightly darker tone and arrange on the remaining stalks. Glue in position to finalize the piece.

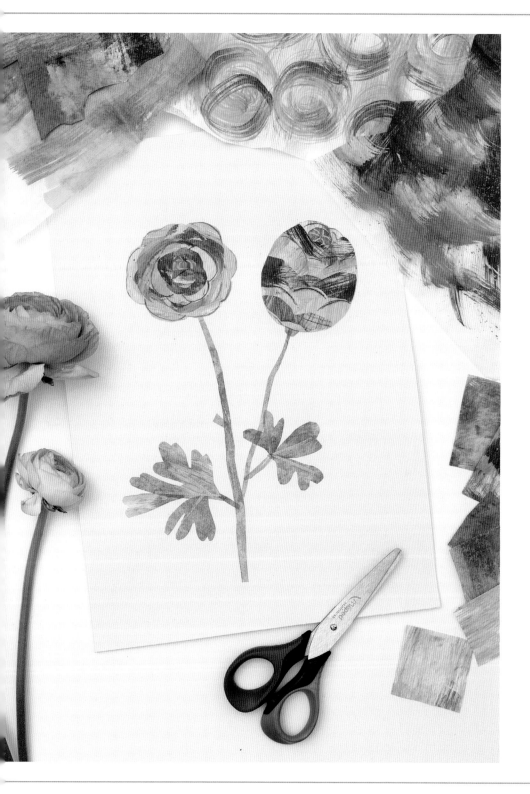

Ranunculus

The ranunculus is an herbaceous perennial from a large genus that contains over 600 varieties; members of this family, Ranunculaceae, include buttercups, spearworts, and water crowfoots. The name derives from the Latin word *rana*, which means "little frog," referring to the fact that the plant favors wet, boggy places. The most popular of the species is the Persian buttercup, *Ranunculus asiaticus*, which is originally native to the eastern region of the Mediterranean and Southwest Asia. They generally can survive frosts and prefer a cool, temperate climate. This flower comes in a variety of intense colors and is perfect for picking.

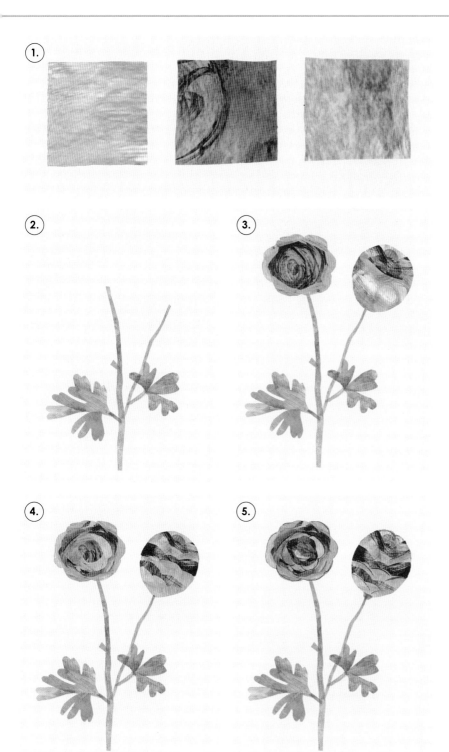

Colors Used:

Naphthol Red Light

Quinacridone Magenta

Permanent Green Light

Olive Green

Titanium White

Step 1: Taking inspiration from the flower heads, create two different tones of pink collage paper. Loosely blend the green paints together to prepare some paper for the leaves.

Step 2: From the prepared green paper, cut out the stem and leaves for the ranunculus. Arrange on the final surface and adhere in place.

Step 3: Cut out the base shapes for the flower heads, position on the stems, and adhere in place. Then, add the first layer of the petals on each base layer. Glue down.

Step 4: Cut out some more petals and continue to arrange the flower heads. Also, cut some thin light green strips to add definition to the leaves. Adhere everything in place.

Step 5: Finally, with a fine brush and darker tone of paint, add some high-lights to the flowers to create some definition and complete the collage.

About the Author

As a child of two artists, Tracey English was destined to work in a creative field. With experience as a textile designer and color forecaster, Tracey currently specializes in illustration and pattern design. She works on commissions and licenses her designs for books, magazines, gifts, and stationery. Tracey English is based in South West London.

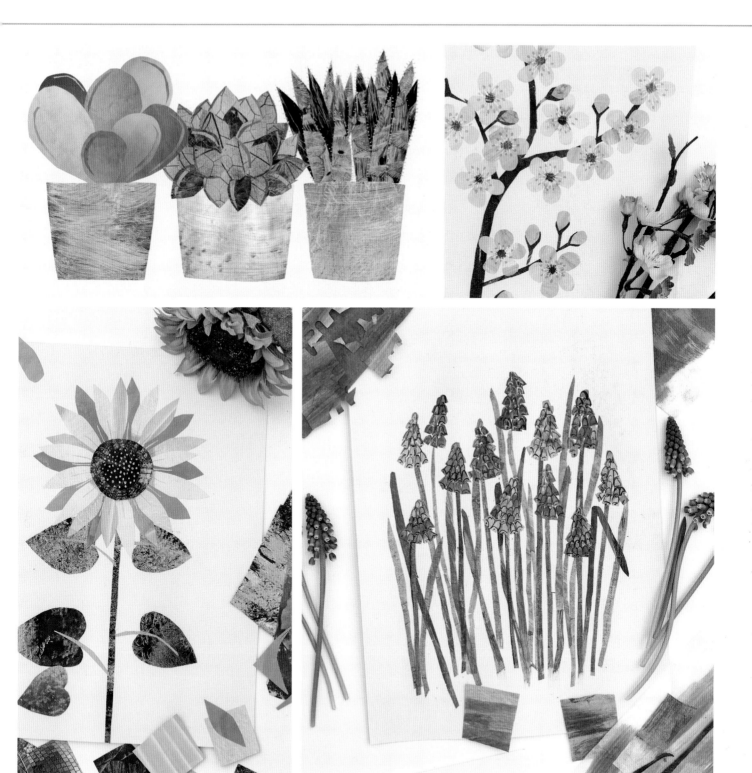

Also Available

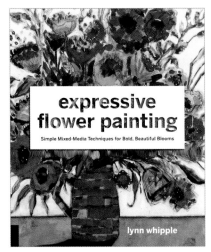

Expressive Flower Painting
978-1-63159-304-8

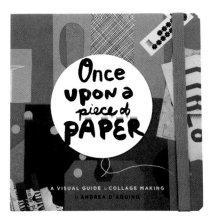

Once Upon a Piece of Paper
978-1-63159-264-5

Classic Sketchbook: Botanicals
978-1-63159-139-6

If You Can Cut, You Can Collage
978-1-63159-335-2